Second Nature

SARAH MALAKOFF
Second Nature

CHARTA

Design
Fayçal Zaouali

Editorial Coordination
Filomena Moscatelli

Copyediting
Emily Ligniti

Copywriting and Press Office
Silvia Palombi

Promotion and Web
Elisa Legnani

Distribution
Anna Visaggi

Administration
Grazia De Giosa

Warehouse and Outlet
Roberto Curiale

Cover
Untitled Interior (canoe table), 2002

© 2013
Edizioni Charta, Milano
© Sarah Malakoff for her photographs
© The authors for their essays

All rights reserved
ISBN 978-88-8158-861-9
Printed in Italy

Edizioni Charta srl
Milano
via della Moscova, 27 - 20121
Tel. +39-026598098/026598200
Fax +39-026598577
e-mail: charta@chartaartbooks.it
www.chartaartbooks.it

No part of this publication may be reproduced, stored in a
retrieval system or transmitted in any form or by any
means without the prior permission in writing of copyright
holders and of the publisher.

Contents

FOREWORD

Linda Benedict-Jones

Photography allows us to see things in a new way. American photographer Garry Winogrand is often quoted for having said, "I photograph to find out what something will look like photographed." When Sarah Malakoff records seemingly normal everyday rooms with her camera, we begin to wonder if we've ever been in such gently curious spaces. Slowly we realize that most spaces are idiosyncratic, even if we don't see it at first glance. It helps to have a trained observer like Malakoff to point it out.

When I was house hunting before a move from Massachusetts to Pennsylvania, I was led through countless homes. The price range didn't vary that much, but the diversity of decoration was astonishing. It was hard to focus on critically important things like the condition of the furnace or the age of the windows when Zebra carpeting in the family room was shouting at me, or the ballroom chandelier suspended in the dining room was speaking a language I'd never learned. The entire process was fascinating because I was reminded how intensely personal our spaces can be, and, by extension, how different I hoped I was from the people who lived in the homes I was shown.

The next time I was given a privileged behind-the-scenes tour of other people's lives was when I met Sarah Malakoff and saw the photographs that are reproduced in this handsome first book of her work. Here we're greeted at an entryway where an ordinary table lamp is magically integrated into a balustrade railing where it illuminates a quaintly elegant, if slightly shabby, space. We walk through rooms large and small where brightly patterned curtains and dark wood paneling take over, as canoes become coffee tables and living rooms accommodate tree trunks. We visit kitchens, dining rooms, bedrooms, and more as we gaze out the window onto snowy landscapes, lush green meadows, or bodies of water. We meet black cats, porcelain dogs, ducks taking flight, and owls minding a fireplace. We enter spaces with leafy sofas and tiled staircases. We cannot help but wonder why someone would have wanted a basement bar to be the stern of an imaginary ship.

The rooms that Sarah Malakoff photographs are empty of people, but they are certainly not devoid of personality. They invite us to conjure up in our imagination the owner of the home, the renter of the room. Quite unlike interior design advertisements, these spaces don't have perfect coffee cups precisely positioned on granite countertops. There are no books about Picasso casually posing on the bedside table. Instead, there is a patchwork quilt of human artifacts: a miniature artificial Christmas tree, a buck keeping watch from a sofa coverlet, a partly finished jigsaw puzzle, an illuminated globe of the world, a mosquito-net-draped bed, a garden chaise longue at an inside attic window, telescopes in a make-believe forest, and a dartboard in the Atlantic Ocean. Each space is carefully transcribed in the warm vocabulary of contemporary color photographs, creating an ensemble greater than the sum of its parts.

In the 1960s, Diane Arbus photographed men, women, and children who were normal in their own eyes yet non-standard, to varying degrees, for others. We were not accustomed to seeing a young man in curlers at home or a husband and wife at a nudist camp in New Jersey. Her portraits of them enabled us to stare at these strangers as long as we wanted, in a way we never would have dared had we been sitting next to them on the subway. With thoroughly different subject matter, Malakoff's portraits of rooms permit us to gaze deeply into the private dwellings of others, and linger there as long as we like.

"The house was quiet because it had to be."

Jen Mergel

A bedroom wall blanketed with snowdrift-white fur softly glows by lamplight. A brick and brass fireplace burns flames through the open eyes of owl-shaped andirons. From a staircase landing, a hollow plastic goose beams over the front hall, like a sentry. These, and each *Untitled Interior* that Sarah Malakoff photographs in New England and beyond, betray a deep-seeded need, as she notes, to pour creativity into "cocoon-like environments."[1] For her, the allure of their comfort-class details is magnetic, as is finding places with the potential to "blend fact and fiction, the real and artifice and [to] inspire imagined narratives." Just as the rooms she presents are carefully arranged, her images have to be as composed as they are—with a quiet distilled clarity, an imperative to describe.

Why compose to describe? In the face of today's complex global uncertainties, why should a photographer from Massachusetts turn a lens on hushed rooms? "Description is revelation," averred Wallace Stevens, a New Englander who wrote profound Pulitzer Prize-winning poems through 1955. His World War II poetry insists how essential our imaginative capacity can be to recreate worlds of order despite great forces of disorder. In lines from his 1945 poem *Description without Place*, he qualifies how transcendent it can be to create an "intenser" reality, instead of simply accepting what one sees:

Description is revelation. It is not
The thing described, nor false facsimile.

It is an artificial thing that exists,
In its own seeming, plainly visible,

Yet not too closely the double of our lives,
Intenser than any actual life could be[2]

In 1947 Stevens's poetry was acclaimed for its confidence that "even on the verge of ruin, a man can recreate afresh his world out of the unfailing utilization of his inner resources."[3] Six decades later, Malakoff's photography flirts with this belief through a more complex mix of uncertainty, criticality, humor, and hope. A 2007 review admires how her photographs "strike an intelligent balance between formal precision and discreet psychological portraiture . . . She documents the architecture that contains our physical lives and traces our noble resistance to letting it define us."[4] As did Stevens's poems, Malakoff's *Untitled Interiors* reveal the calming power of inner spaces, both in art and life. They are quiet because they have to be. Yet her images seem to question how these spaces save us from outer reality, or whether they placate us with illusions.

To what degree these comfortable interiors—for vacations, guests, games, bars, or beds—seem more a haven or a cage is the key subtext here. Malakoff's photographs make "plainly visible" an artificial intensity, and poignancy, in the choices that make a house a home: décor and furniture, art and architecture, even indoor pets and outdoor views. And her inspired descriptions *are* revelations. Her imagery is a window onto her own need, and ours, to build a nest, to order life regardless of unrest—an impulse we carry with us from childhood to create what she says is "an illusion of safety and warmth or a way to recall the moments that really were that way."

[1] Sarah Malakoff, in correspondence with the author (December 28, 2012). Unless otherwise noted, all artist quotes from this correspondence.
[2] Wallace Stevens, "Description without Place," in John N. Serio (ed.), *Wallace Stevens: Selected Poems*. New York: Alfred A. Knopf, 2011, page 181. First published in the *Sewanee Review* (October 1945) and then *Transport to Summer* (1947).
[3] F.O. Matthiesen, "Wallace Stevens at 67," *New York Times* (April 20, 1947). Accessed December 30, 2012:
http://www.nytimes.com/books/97/12/21/home/stevens-summer.html

In this book review of Stevens's 1947 release *Transport to Summer,* he observes: "All of Stevens's later work has been written against the realization that we live in a time of violent disorder. The most profound challenge in his poems is his confidence that even in such a time, even on the verge of ruin, a man can recreate afresh his world out of the unfailing utilization of his inner resources."
[4] David Coggins, "Sarah Malakoff at Plane Space," *Art in America* (April 2007), page 137.

Review her photographs and consider how many sentinels guard the quiet of each house. Find not only a glowing goose or iron owl, but a lion posted at a blind corner, a buck looking over its shoulder, a duck staring down from a bureau, a German shepherd smiling by a bedside, even a telescope at a window. Each betrays a compulsion—to be watchful and to be watched, and be distractedly admired or used.

Yet each also reminds us of a need to be on guard. We must hark what might be outside the night window, below the staircase door, through the blinds, waiting to be tangled in the garden hose, or what might be under the proverbial bed. Were there a soundtrack to these silent images, Malakoff considers Angelo Badalementi's instrumental compositions for the David Lynch TV murder mystery *Twin Peaks* a strong inspiration, explaining they are "beautiful and lush, seemingly familiar but fraught, a little dark and mysterious—somehow a little humorous, too." The stillness she creates invites listening for such feeling that might otherwise be overlooked.

In her recent essay, "Make Yourself a(t) Home," curator Aprile Gallant observes: "Most people are not completely aware of the desires and anxieties their décor project . . . One of the strengths of Malakoff's view of these interiors is that she finds the precise angle that unravels the illusion, and make the concepts behind the arrangements simultaneously legible and strange."[5] Malakoff's art, her "precise angle," harnesses this Lynchian mood with "intenser" description to reveal contradictory signals. That is, there is a poetic tension in Malakoff's photography: each image balances degrees of opposing forces—of unrest and refuge, anxiety and curiosity, fear and calm—through a formal quiet that speaks loudly.

The poetry of Malakoff's precision is that it is not an end but a means. Her attention to texture, lighting, and focal points do not merely depict. Rather they *describe*, as they establish rhythm, tone, and metaphoric double readings between what is there and what seems to be. Importantly, Malakoff presents each *Untitled Interior* room not as a document of a specific place, but as a *description without place*—as Stevens limned, "seeming is description without place, / The spirit's universe."[6]

Malakoff can capture the spirit of a room. Her precision can turn a long dining table in a room surrounded by windows into a metaphorical birdcage or trap, in *Untitled Interior (birdcage table)* [pp. 22–23]. Upon the table, two bird figurines may have escaped from the empty round cage in the corner, but they are not free among the trees, and neither is anyone who gathers near by the weak lamplight or toy tree. Echoing cage bars, the vertical jambs between each windowpane keep indoor residents "safe" from the brighter, wider outdoors.

This pressure and permeability between inside and outside, tamed and untamed is what can make Malakoff's rooms feel so animated, even animate. She stills our view on these interiors so we can see how nature seeps in as culture projects outward. Her rooms expand and contract. They breathe not only metaphorically, but also visually, because she frames and lights them to seem both revealing yet constrictive, inviting but imposingly compressed. Note how in *Untitled Interior (deer couch)* [p. 29], the tucked seam of the afghan breaks the legs of the trapped buck, but also breaks the spatial plane of the image. See how the painted sunlight beaming within the painting above the couch seems the source of glinting light on the gold frame and walls as well. Broken nature and culture fold into each other in disorienting ways.

[5] Aprile Gallant, "Make Yourself a(t) Home," in Sarah Malakoff, *Living Arrangements*. Self-published catalogue, 2011, pages 2-3.
[6] Stevens, page 180.

There is a sense of potential collapse or puncture in many of Malakoff's images. The glowing wall-inset aquarium in *Untitled Interior (aquarium)* [p. 67] could seem like a painting, yes, but also window to a vast ocean beyond the wall with only the closed door to keep us from a flood of sea life pouring in. The patterns of rings on the cast-tin ceiling could also seem like ripples on the surface of water above, as if we are already underwater, trapped in an airless aquarium with patterned pillows as our decorative coral to swim around. Feeling submerged also comes in *Untitled Interior (plaid sofa)* [p. 55], which is backed by a wall of stones carefully stacked to suggest a secret underground cave or lair, with an anachronistic phone at hand to call another time. As George Slade observes, "What Sarah Malakoff shows us is the built environment in flux, interiors as manifestations of transformation, and taste, or design intention, as a means to an entropic, inward-collapsing end."[7] These rooms could be silently heaving.

These subtle swells can be felt because Malakoff deliberately highlights emotional facets that glint as we turn her images over in our minds. You can feel the distinct pathos between the desiccated gloom of *Untitled Interior (xmas tree)* [p. 19] and the airy veils of light promise in *Untitled Interior (b in white room)* [p. 71]. Both images present an empty floor, then seating before curved white curtained windows, with a white "character" taking center stage. Despite their similar formats, the former image feels comically dark, as if its flat-lit black sofa begrudges the cheer of the season, while the latter hints a peaceful assurance: the cat lays down with the whale as if the lion with the lamb, and the phone and lamp ring no alarm, only good news.

Importantly, Malakoff's details are easy to anthropomorphize because she wants them to be. In her images, the fabric patterns, pillow textures, lamps of all shapes and sizes, books and pets and plants on tables, the body shape of chairs, and more, all reflect taste and personality of course. But from Malakoff's precise angle, each also becomes a narrative "character" who defines the prevailing mood and influence of the interior. Even in the more understated scenes, the items she depicts seem to know something we don't. In *Untitled Interior (dictionary)* [p. 60], the guardians watching over the room are two candelabra sconces whose electric light warms against cool light outside the window. Perhaps they announce some magic ritual is about to unfold. Precious porcelains are safely tucked away on dark wooden shelves, and in contrast, taking center stage is the distinctive Saarinen silhouette of a minimalist white table, the outsider, but also the presenter. It offers an open dictionary, with light reflecting from each finger tab progressively stepping through the alphabet, perhaps landing between definitions of "tea" and "teach." The dictionary waits for those who seek.

So why describe through such characters? Is now the time to focus on minute detail through such poetic reverie? Elizabeth Bishop offers an affirmative answer: "Writing poetry is a way of life, not a matter of testifying but of experiencing. It is not the way in which one goes about interpreting the world, but the very process of sensing it."[8] Bishop, another great voice from New England whose humanist poetry throughout the Cold War era won the Pulitzer Prize the year after Stevens, has been praised for qualities echoed in Malakoff's art: "Bishop's poetics is one distinguished by tranquil observation, craft-like accuracy, care for the small things of the world . . . Her poems are balanced like Alexander Calder mobiles, turning so subtly as to seem almost still at first, every element, every weight of meaning and song, poised flawlessly against the next."[9]

[7] George Slade, "Domesticated Interiors: Sarah Malakoff," *Northeast Exposure Online: Photographic Resource Center at Boston University* (November 2010). Accessed December 30, 2012:
http://www.prcneo.org/index.php?exhibit_id=21#members/21/21_fe_14.jpg

[8] See Regina Colonia, "Poetry as a Way of Life," in George Monteiro (ed.), *Conversations with Elizabeth Bishop.* Jackson: University Press of Mississippi, 1996, page 51. First published in *Jornal do Brasil* (Rio de Janeiro) (June 6, 1970), page 8.
[9] Ernest Hilbert, "Elizabeth Bishop," *Bold Type,* vol. 4.5 *Mailaise* (September 2000). Ac-

The precise angles and emotional facets stilled in Malakoff's photographs share the strengths of Bishop's poems, whose expressive precision is epitomized in her masterwork, *Sestina* (1965). Each of this poem's seven stanzas re-sequences our relation to six characters—the child, tears, stove, house, grandmother, and almanac—to capture place, childhood memory, and the interior power of a room. The third stanza brings objects to life as a kettle cries, rain dances, and an almanac is "clever":

It's time for tea now; but the child
is watching the teakettle's small hard tears
dance like mad on the hot black stove,
the way the rain must dance on the house.
Tidying up, the old grandmother
hangs up the clever almanac[10]

By the fifth stanza, the stove and almanac speak, and the child begins to animate through an image:

It was to be, says the Marvel Stove.
I know what I know, says the almanac.
With crayons the child draws a rigid house
and a winding pathway. Then the child
puts in a man with buttons like tears
and shows it proudly to the grandmother.

In the final stanza, Bishop's turned words finally land in place, a scene of living through a loss and carrying on in a haunted room:

Time to plant tears, says the almanac.
The grandmother sings to the marvelous stove
and the child draws another inscrutable house.

Bishop's knowing almanac and Malakoff's knowing dictionary offer poetry as a "way of life, not a matter of testifying but experiencing." They are testament to the human desire to understand, not simply by fact, but by feeling. They recall a sense of what is and isn't safe, who is absent yet still present, and why we continue searching. Their "care for small things of the world" reminds us how to face the big things. Like Bishop and Stevens before her, Malakoff reveals inner spaces that may give us, not absolute confidence or certainty, but something more important: the power to see and sense discerningly. They offer a quiet that reminds us to keep our ears up, to look beyond.

Malakoff's *Untitled Interior (planet book)* [p. 70] suggests the hush of a summer night, about to be charged with some epiphany. As if an indoor campsite, a blanket shares a bare wood floor with an open book of constellations and an LP record player. Instead of a lantern or lightening bug, a lone nightlight in the wall socket glows against the window view of sky fading through a forest. The scene is speechless, pregnant with imminent wonder: is a star, or new life, or a new discovery about to fall from the sky? In 1947, Stevens penned lines about why we need such scenes in our lives:

The summer night is like a perfection of thought.
The house was quiet because it had to be.

cessed January 24, 2012:
http://www.randomhouse.com/boldtype/0900/bishop/essay.html
In this review of *The Voice of a Poet: Elizabeth Bishop,* poet Ernie Hilbert remarks: "The falling away of detail into experience, and, above all, the belief that no detail is too small to be of significance, is emblematic of the dominant energies of her poetry. This is her great strength, that while the world waited on the brink of war, she could use the human concern for detail to create works of art rather than political hostility. Unquestionably one of the most important American poets of the century, Bishop's poetics is one dis-

tinguished by tranquil observation, craft-like accuracy, care for the small things of the world, a miniaturist's discretion and attention. Unlike the pert and woolly poetry that came to dominate American literature by the second half of her life, her poems are balanced like Alexander Calder mobiles, turning so subtly as to seem almost still at first, every element, every weight of meaning and song, poised flawlessly against the next."
[10] Elizabeth Bishop, "Sestina," in Alexander W. Allison et al. (ed.), *The Norton Anthology of Poetry: Third Edition.* New York: W.W. Norton, 1983, pages 1142–1143. Composed in 1956 and first published in *Questions of Travel* (1965).

The quiet was part of the meaning, part of the mind:
The access of perfection to the page.

And the world was calm. The truth in a calm world,
In which there is no other meaning, itself

Is calm, itself is summer and night, itself
Is the reader leaning late and reading there.[11]

A transcendent insight about ourselves and our connection to the world can come from focus within the quiet house. As Stevens most famously stated, "Poetry is the statement of the relation between a man and his world."[12] Malakoff's images recognize this poetic need to relate to our world, to wonder about relation. Her precise angle of focus on each character in her images comes alive because she sets the stage of calm: "The house was quiet because it had to be." She pursues this quiet framing, as Stevens did through World War II and Bishop did through the Cold War, as a way of finding our place. For Malakoff, the defining idea of her art can be felt in the soulful, searching song lyric "When you know where you are, you're inventing it."[13] Whether we domesticate these interiors or they domesticate us, Malakoff invites us to lean in, to imagine, to invent, and to find our very selves in their quiet.

[11] Stevens, "The house was quiet and the world was calm," in *Wallace Stevens: Selected Poems,* page 186. First published in *Transport to Summer* (1947).
[12] Wallace Stevens, *Opus Posthumous,* Ed. Samuel French Morse. New York: Alfred A. Knopf, 1957, page 172.
[13] Richard Davies, "You've Lost Me There" with Eric Matthews as Cardinal on *Cardinal,* first released 1994.

PLATES

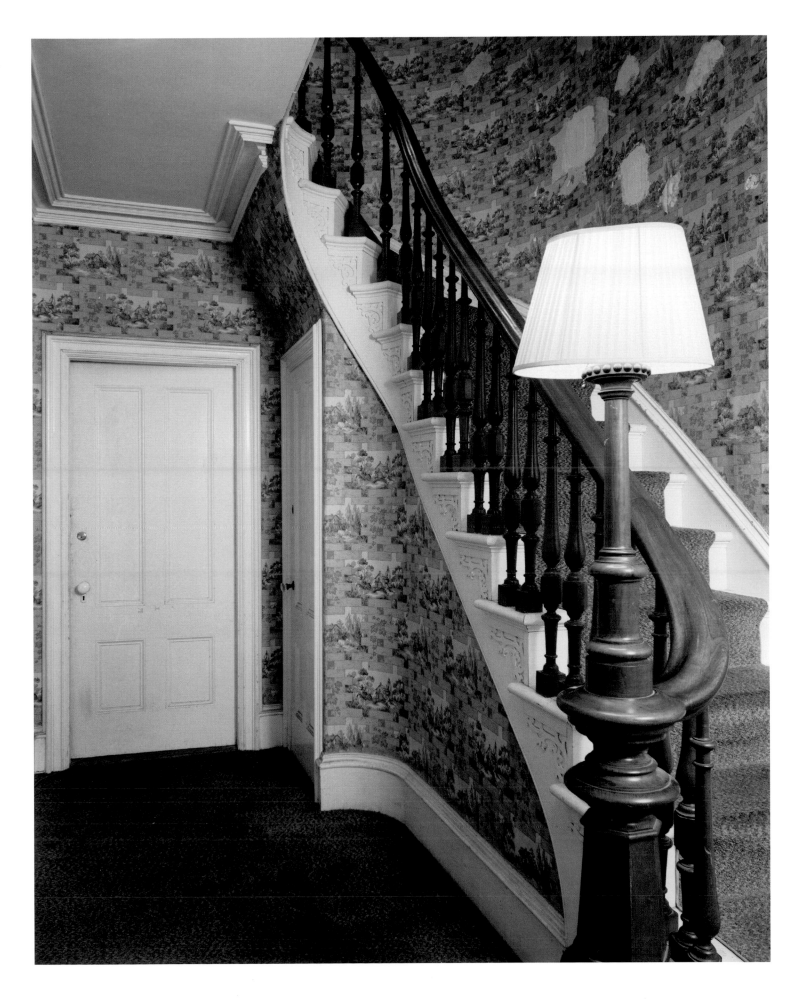

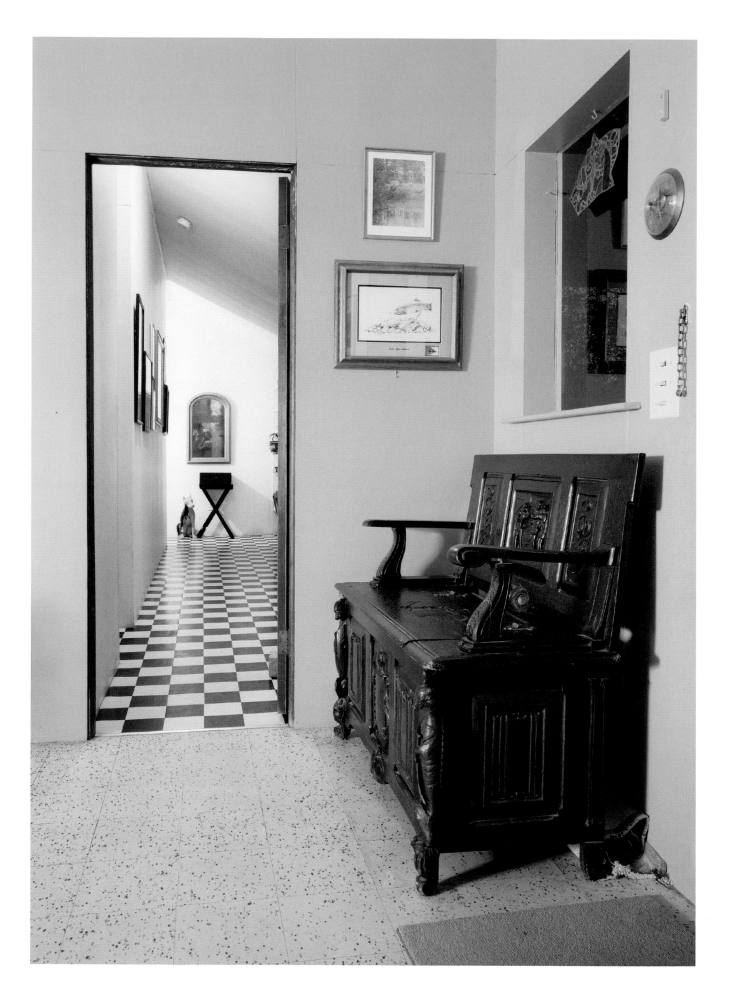

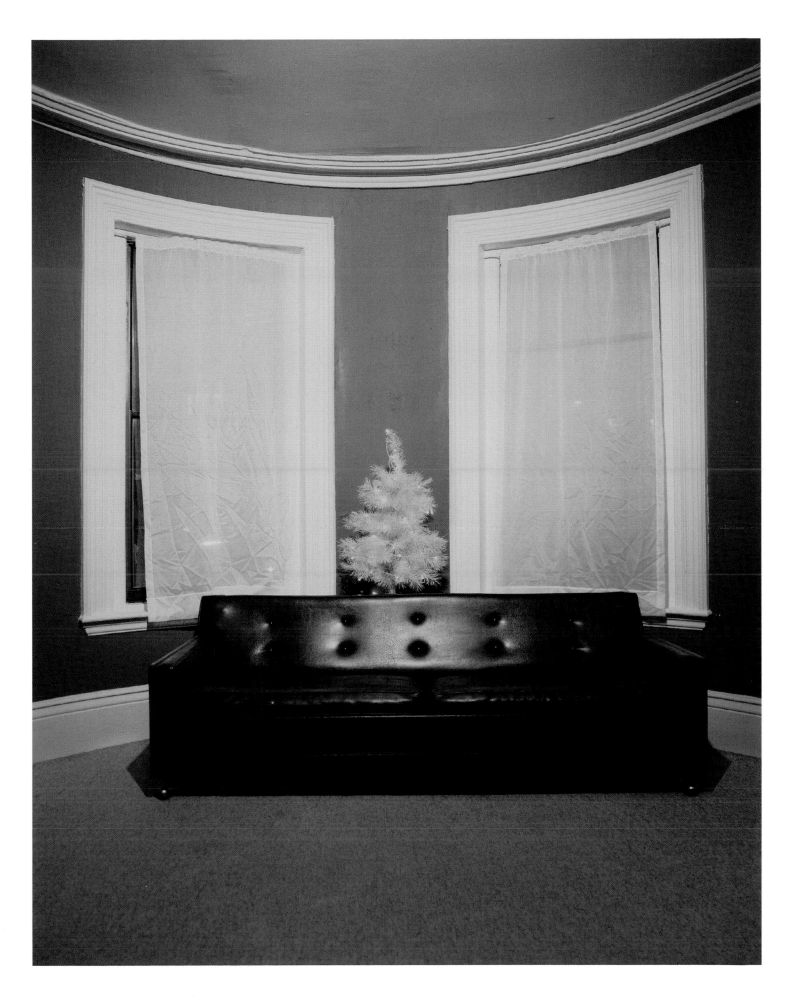

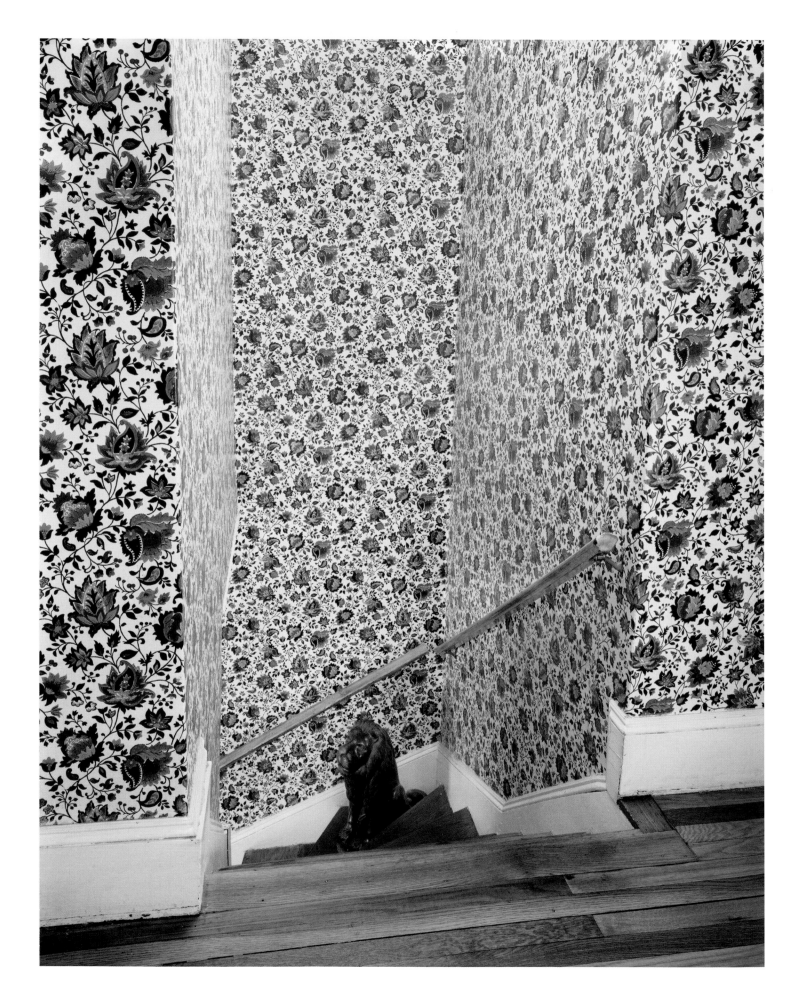

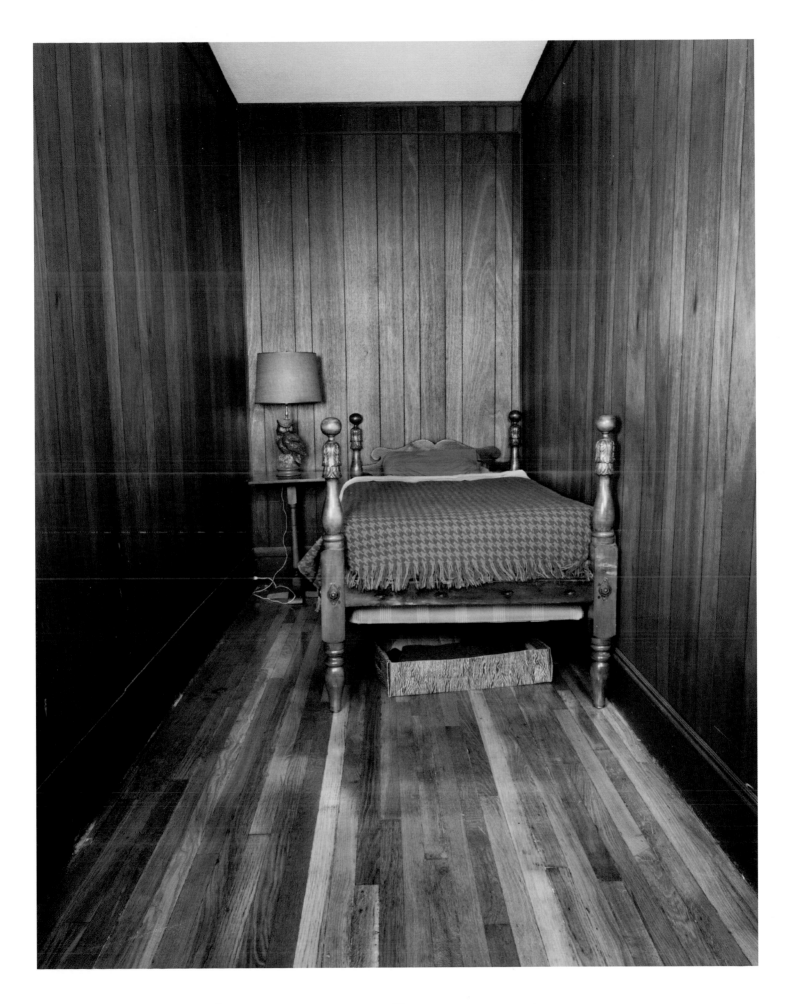

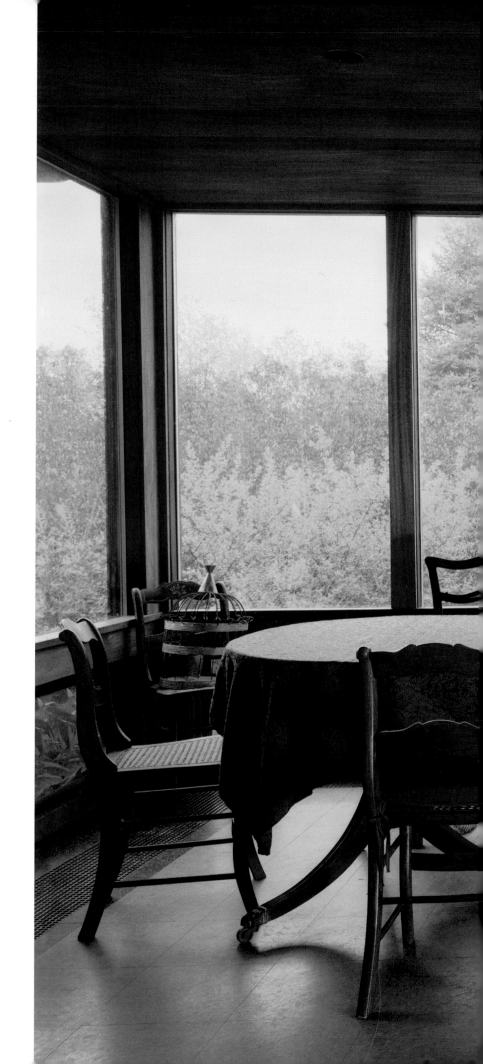

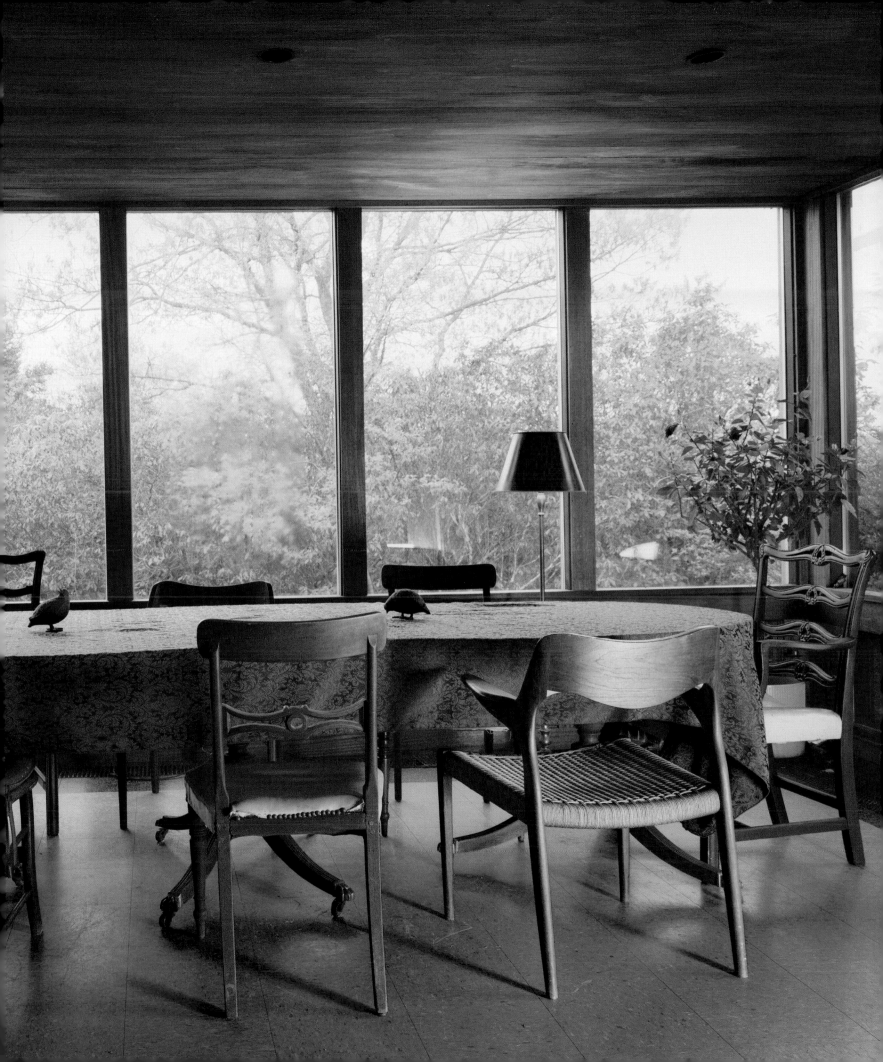

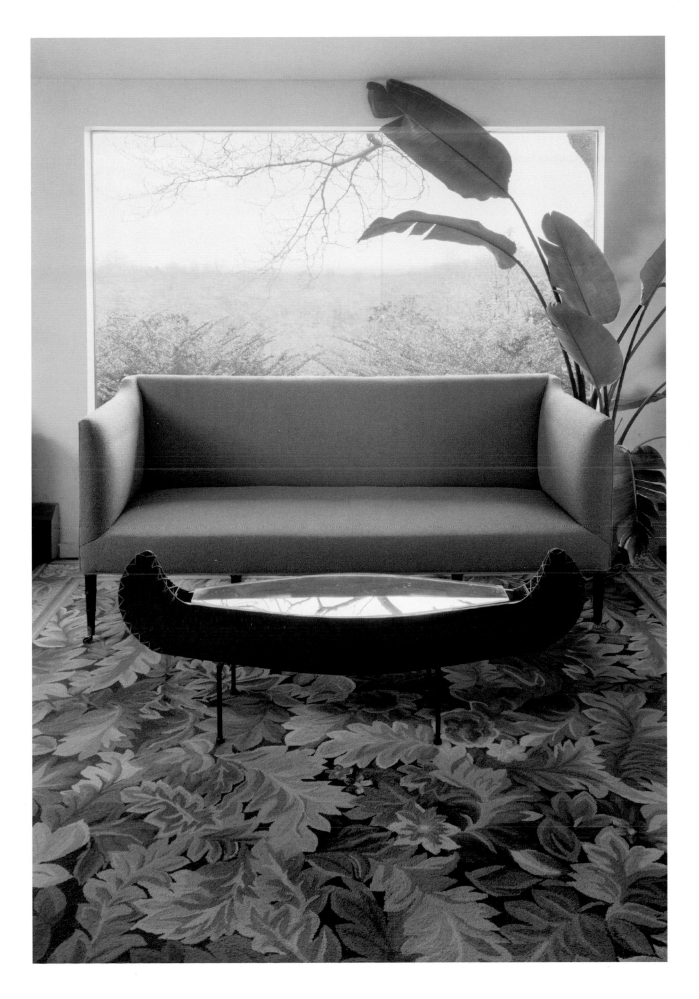

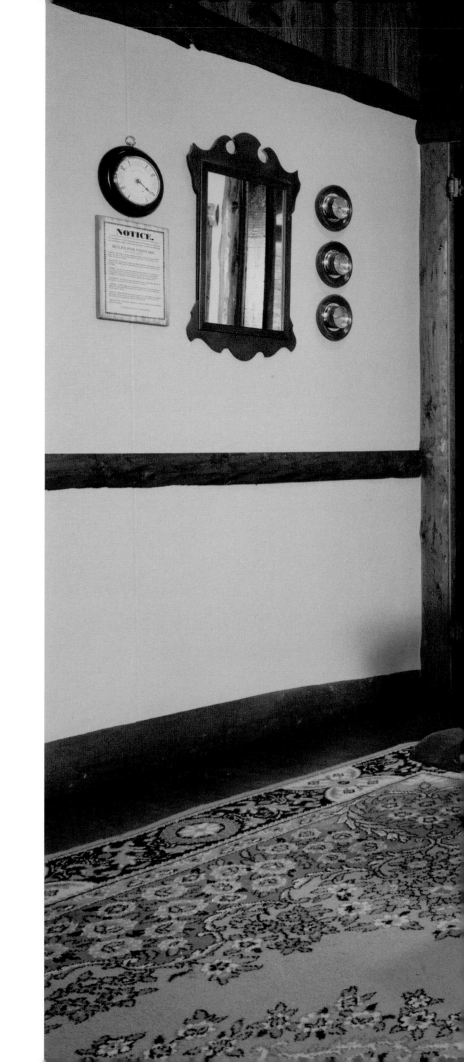

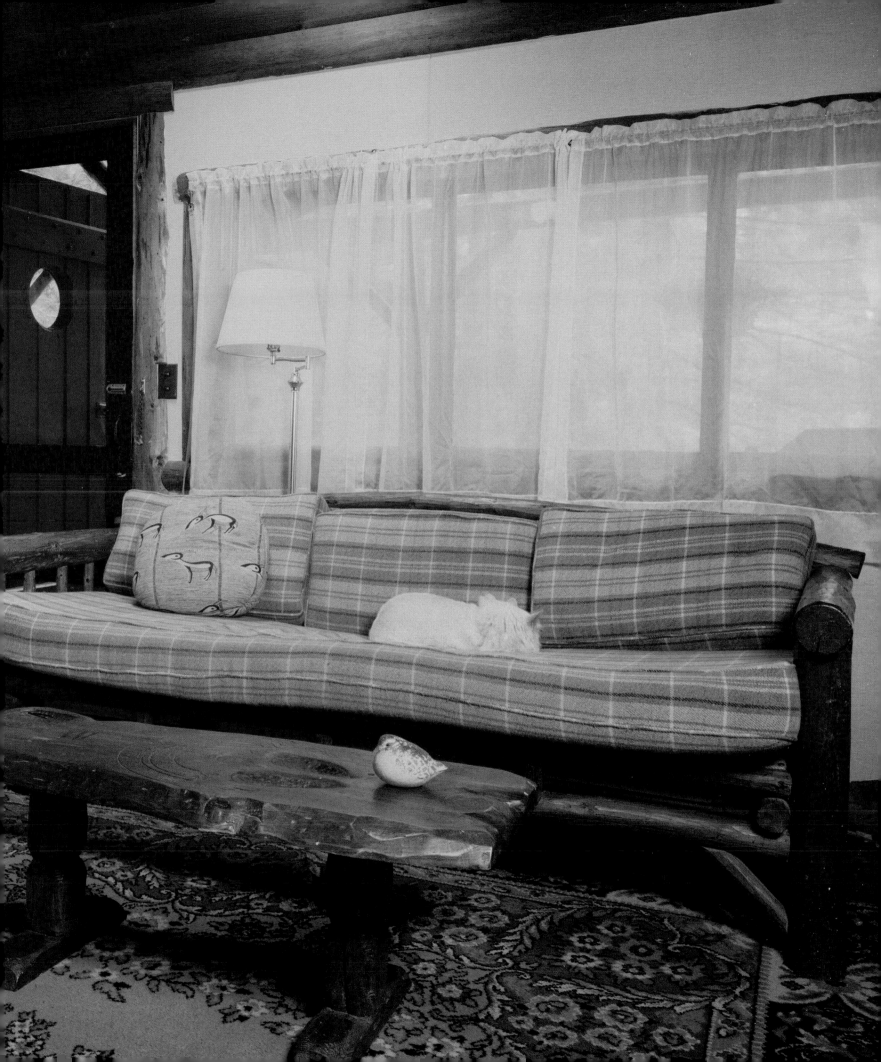

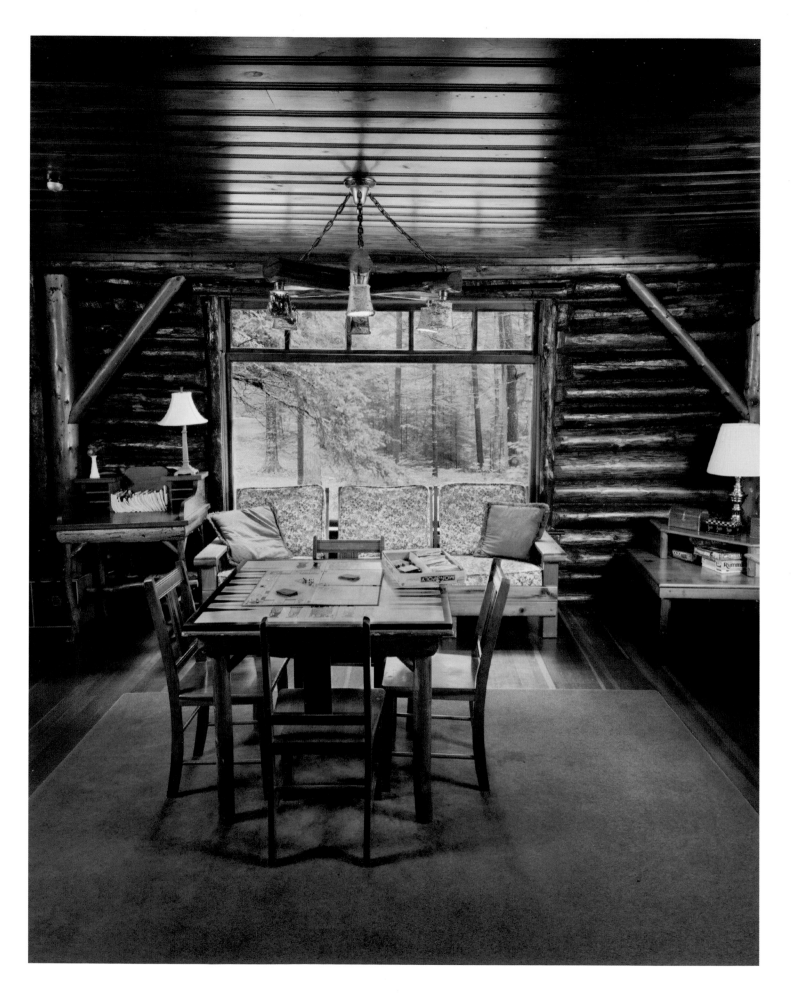

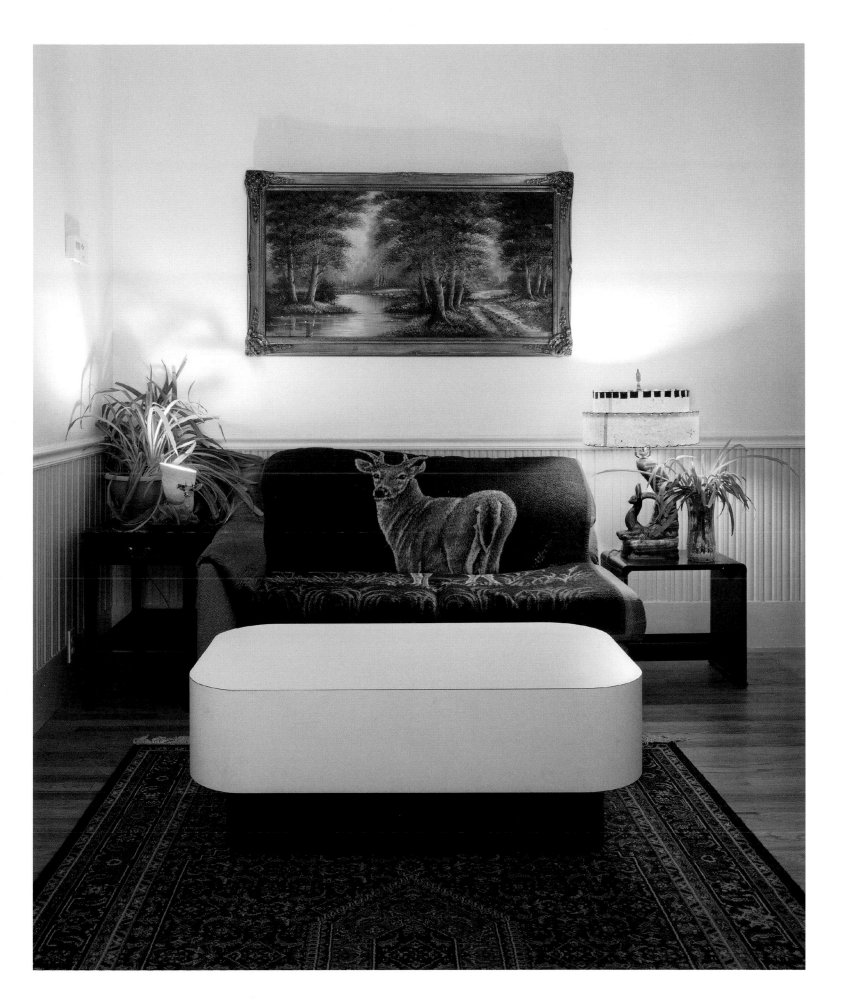

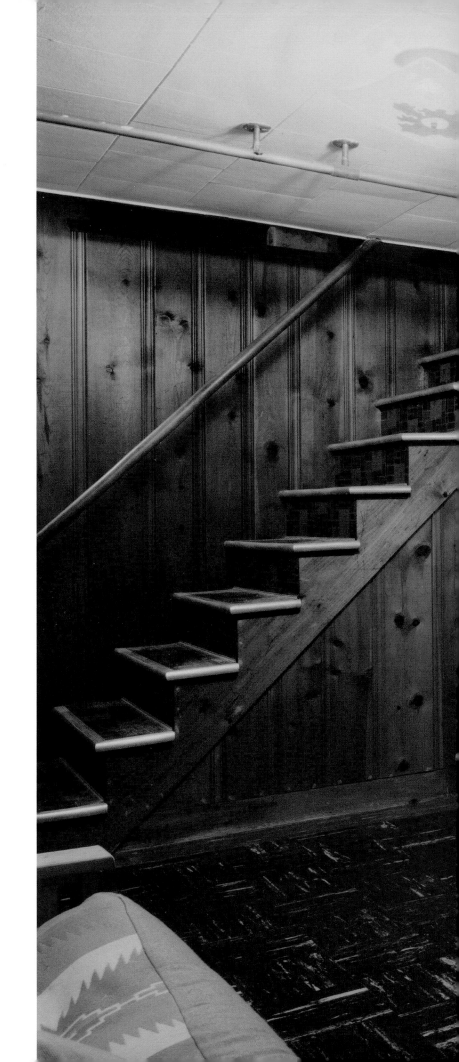

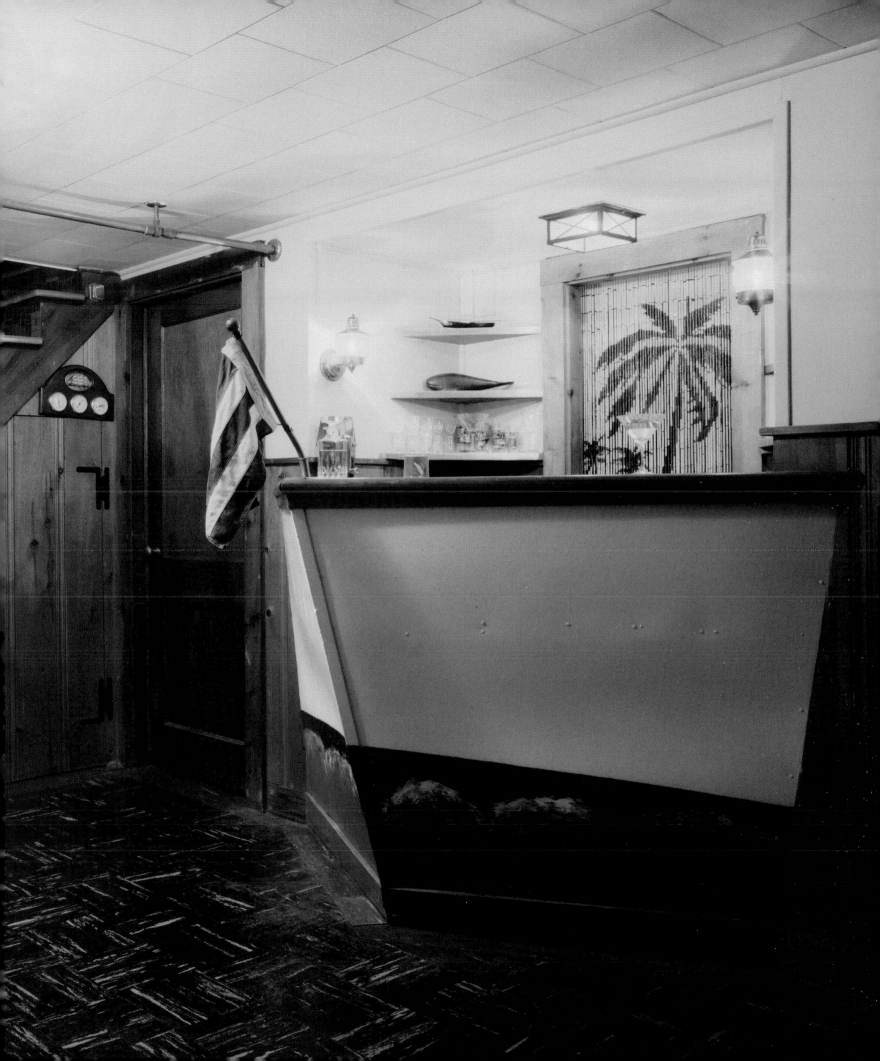

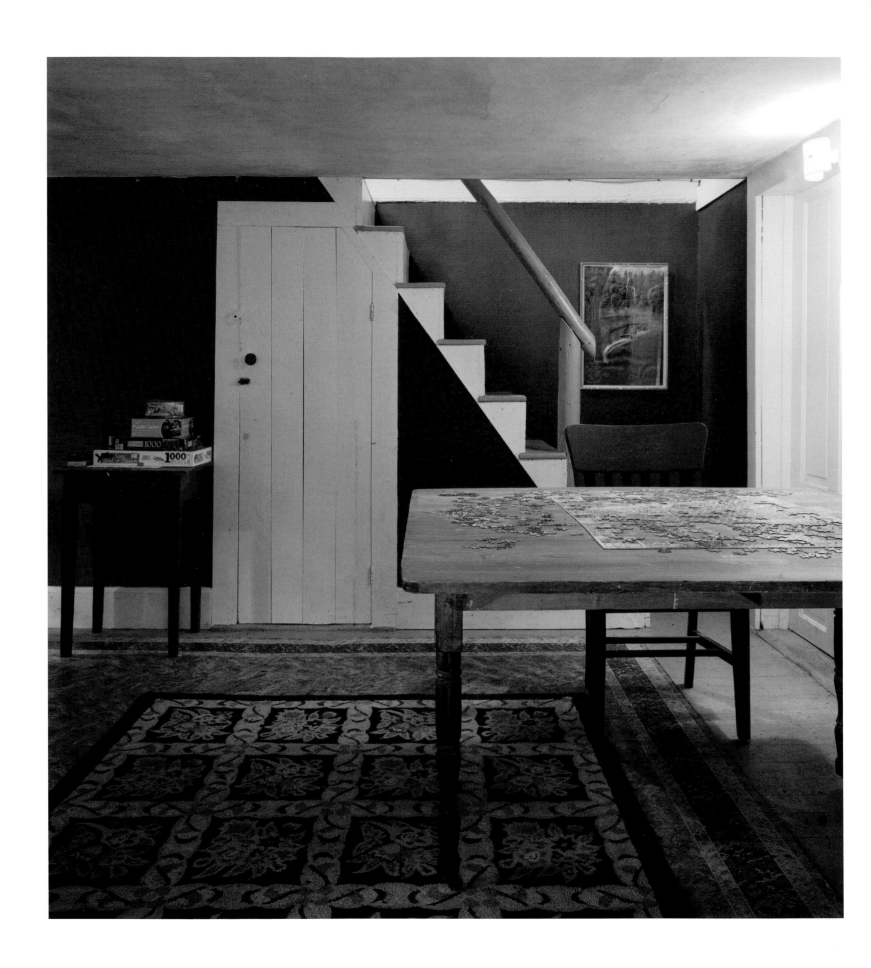

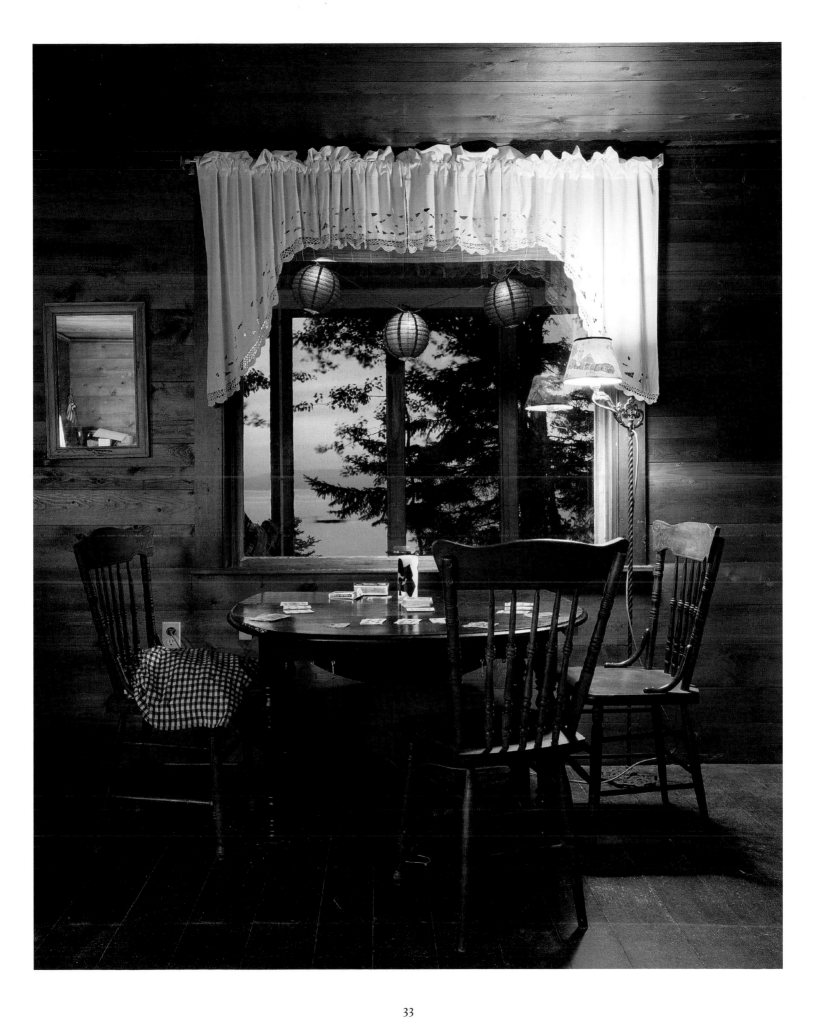

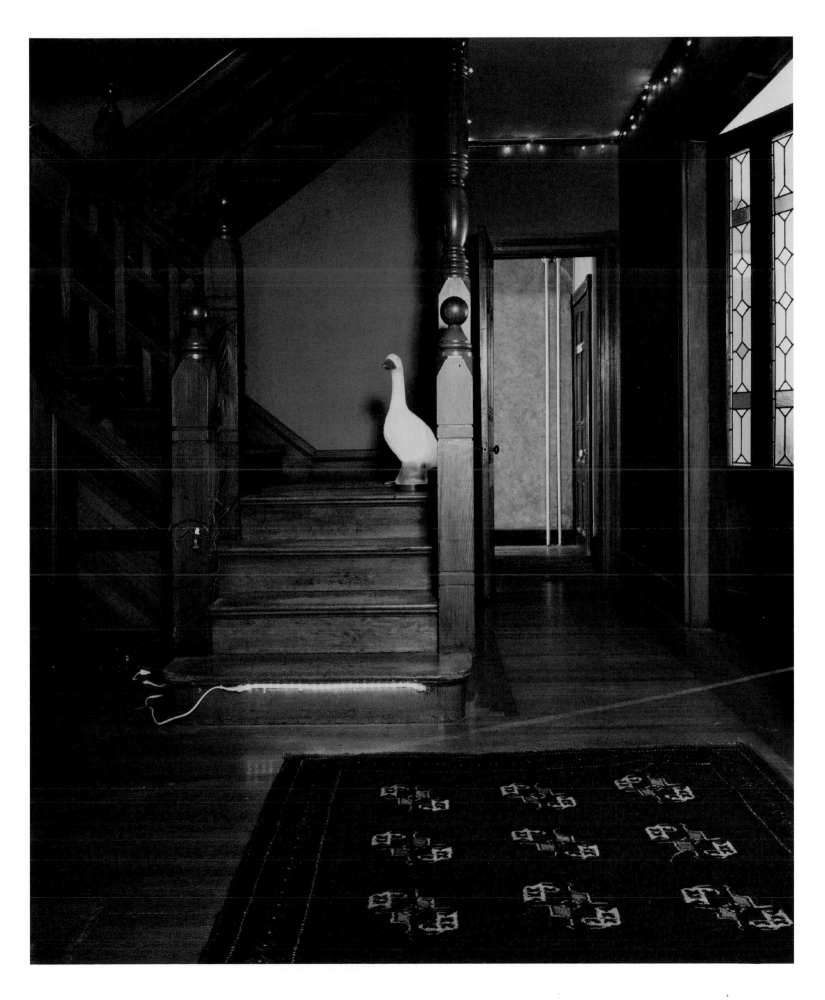

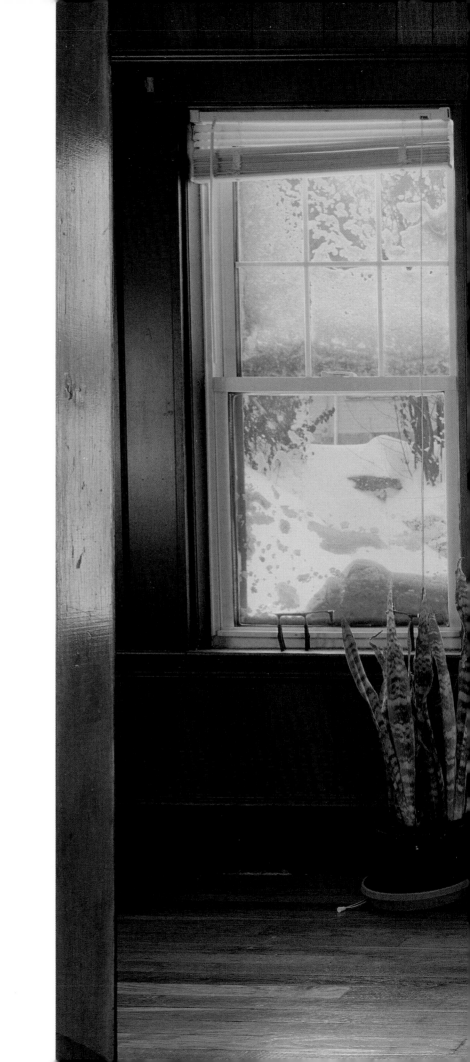

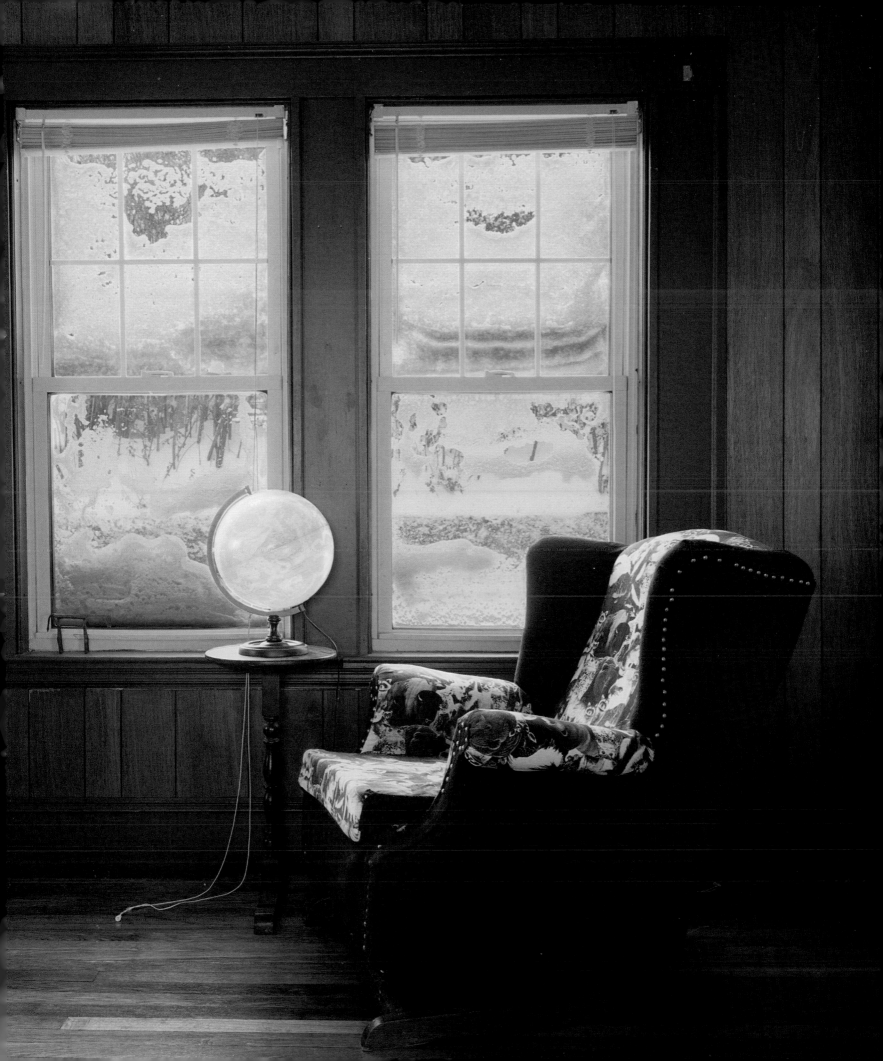

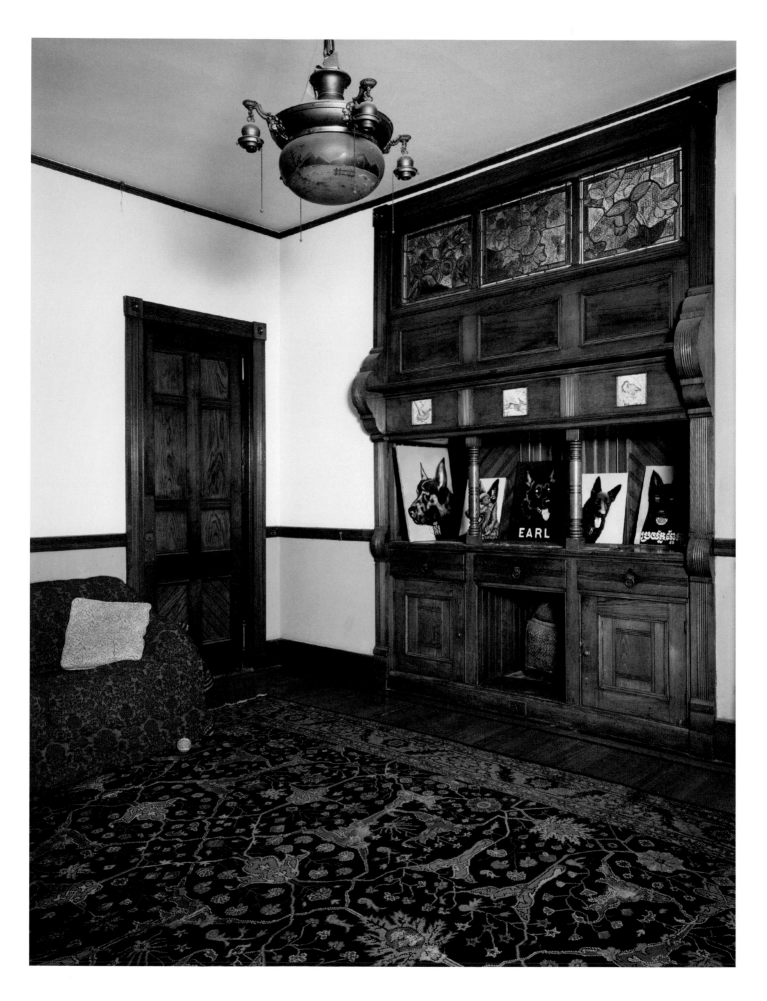

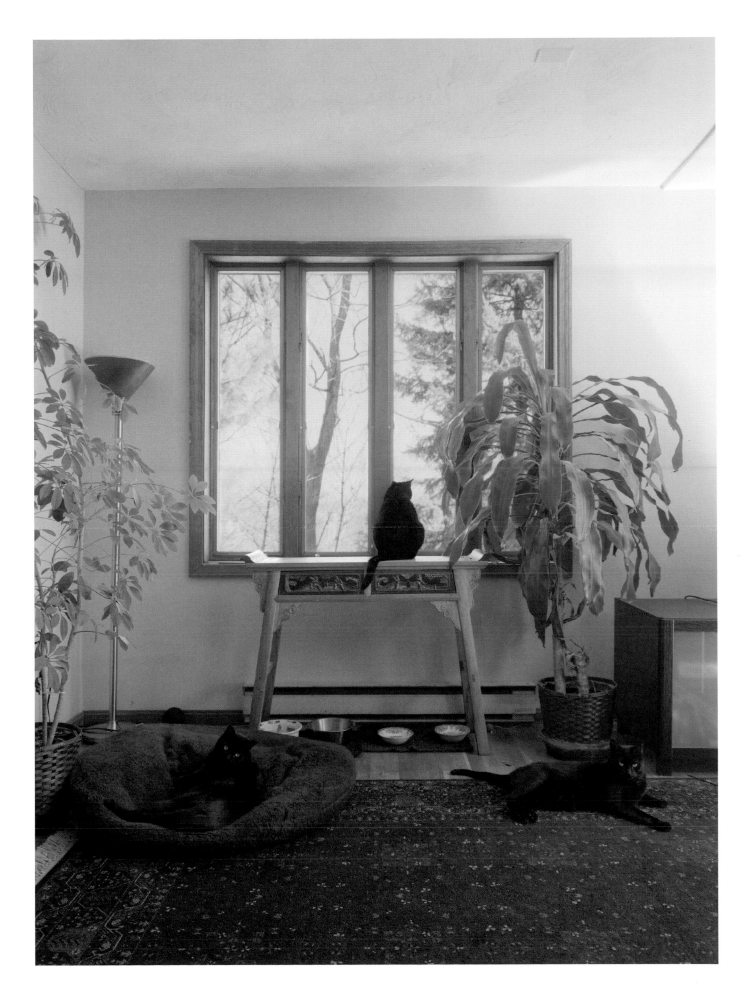

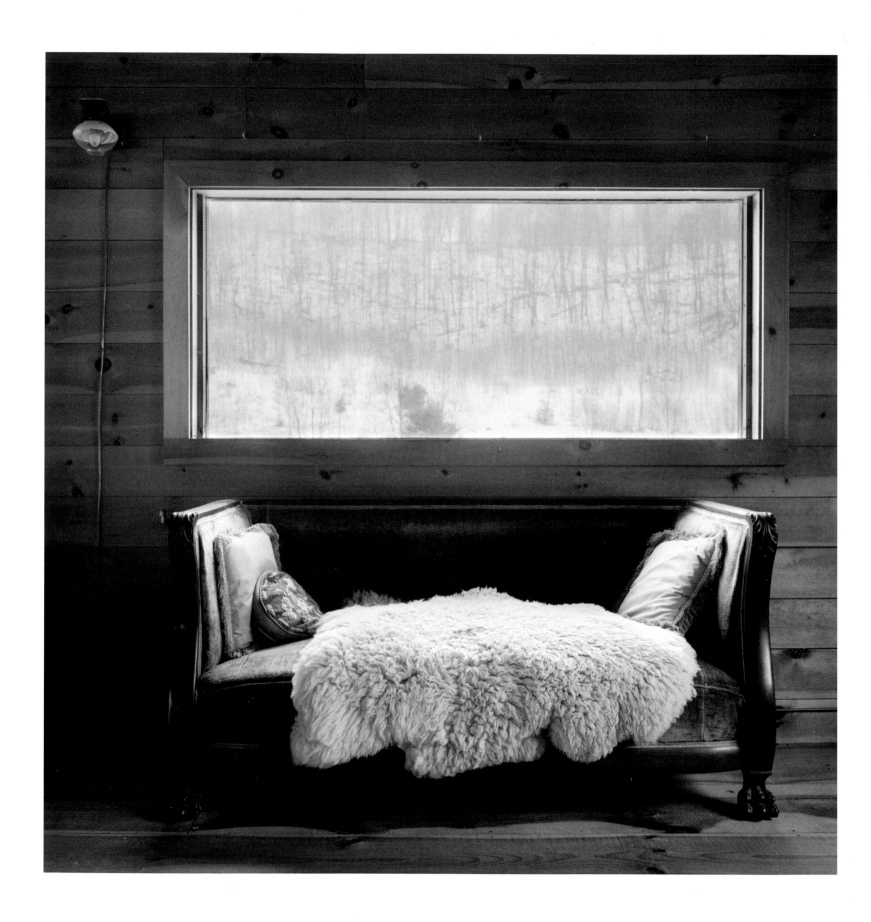

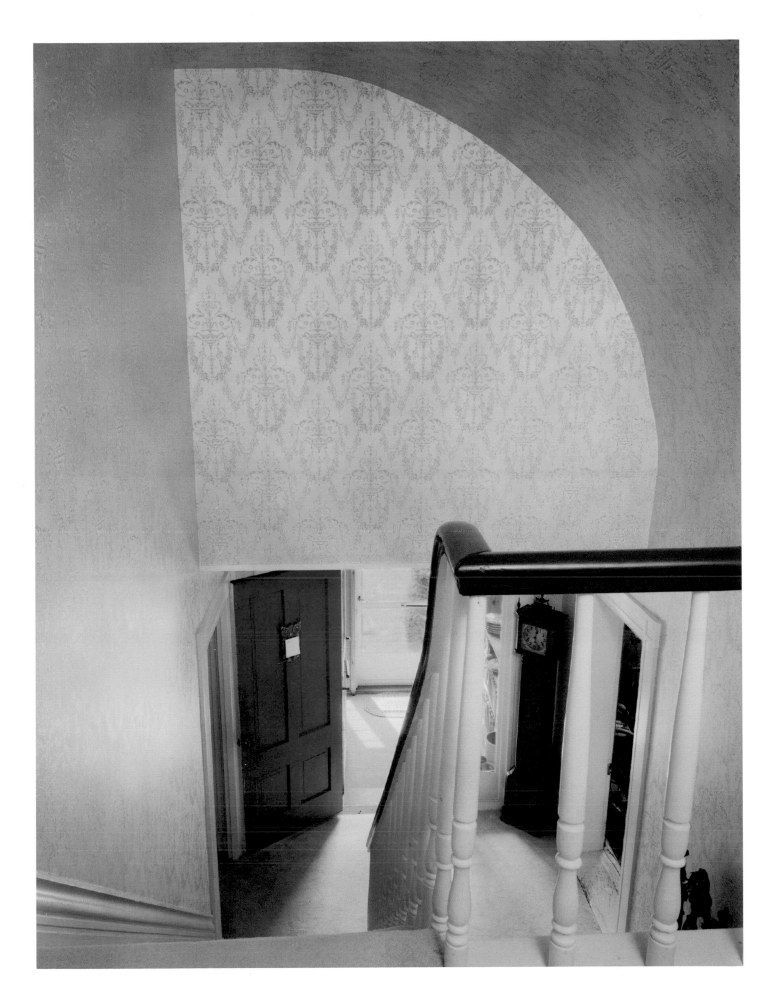

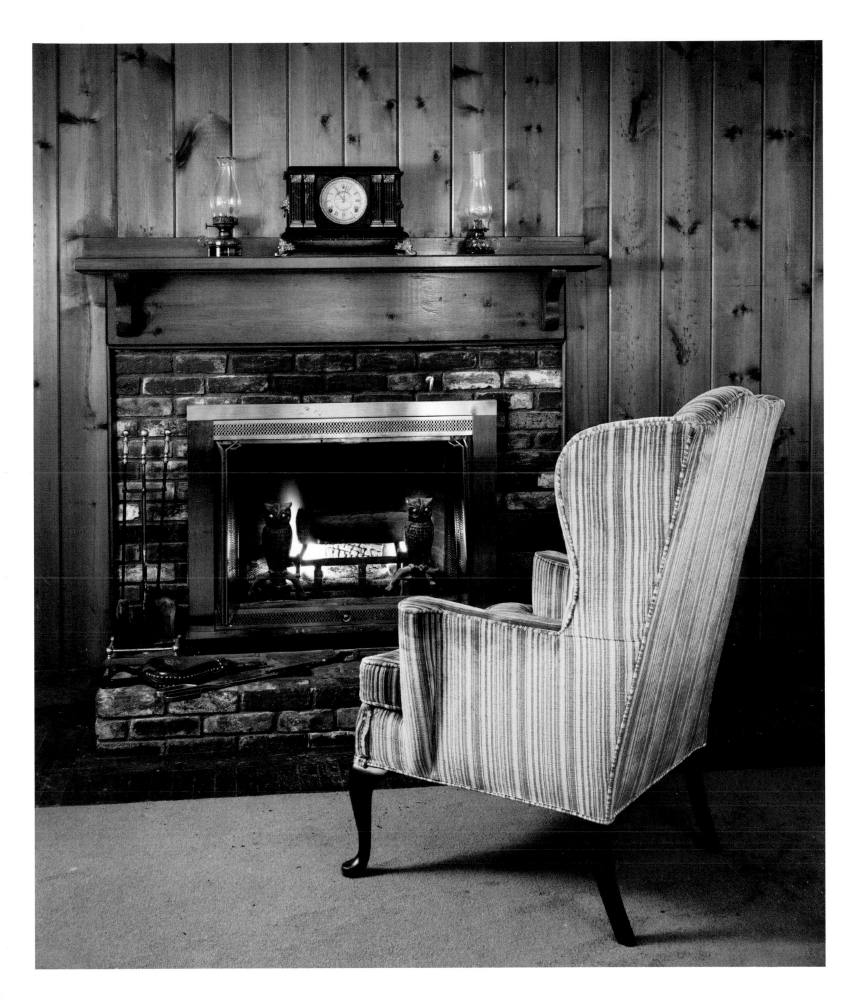

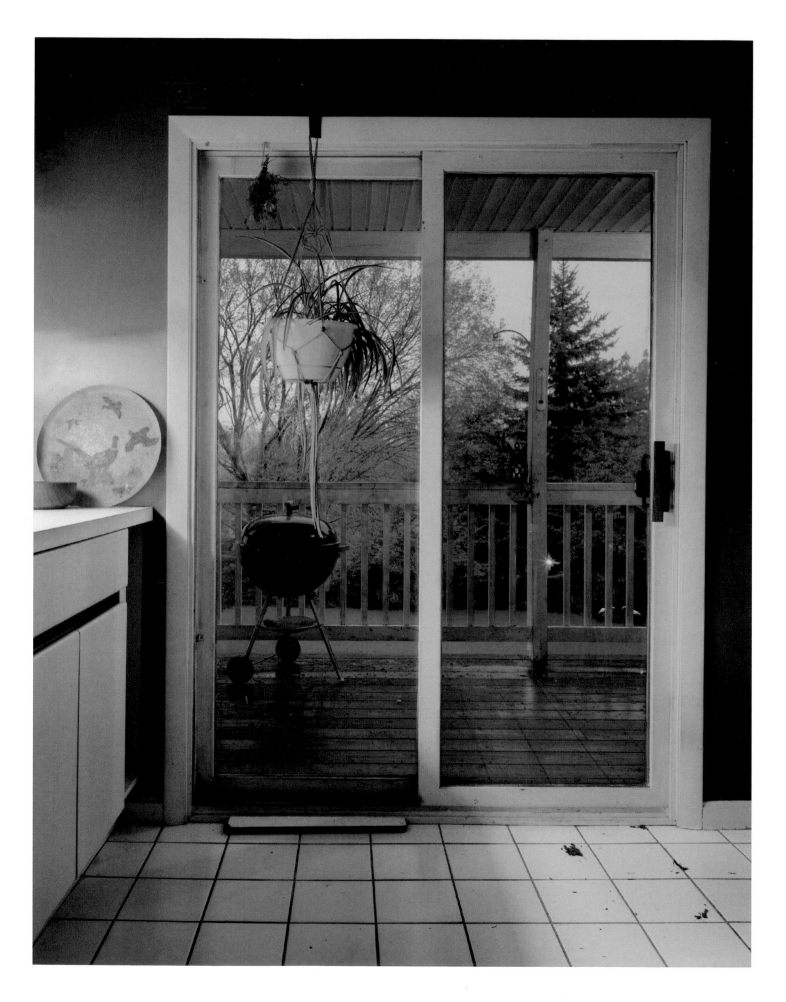

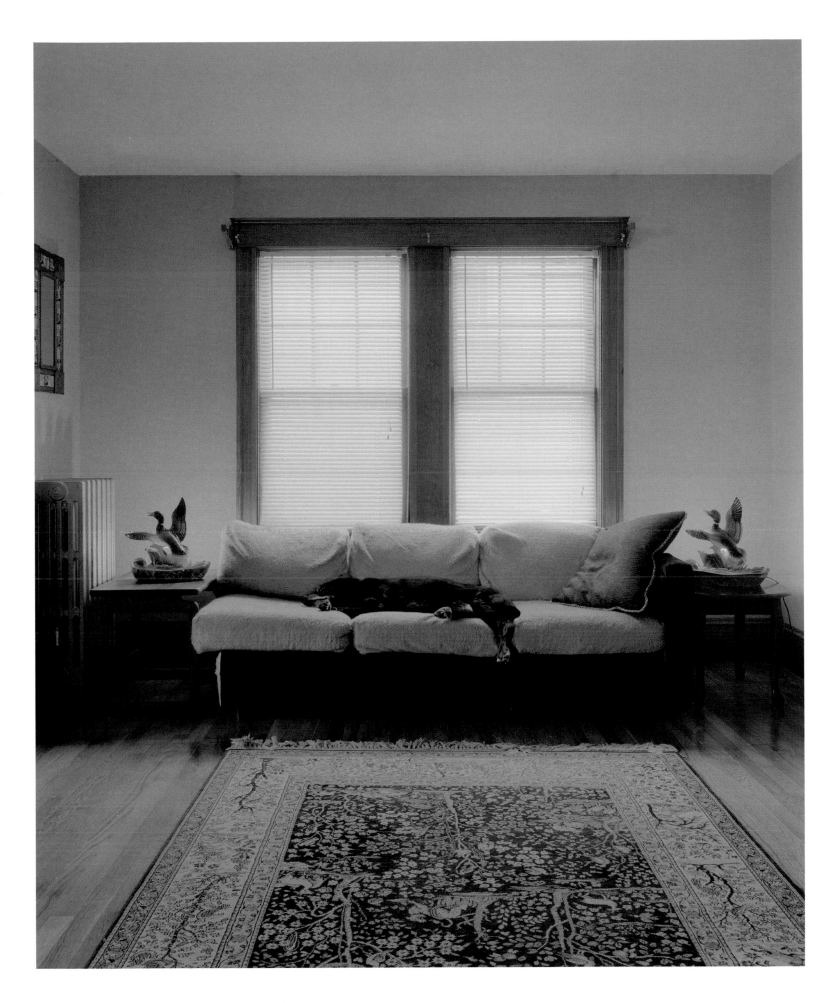

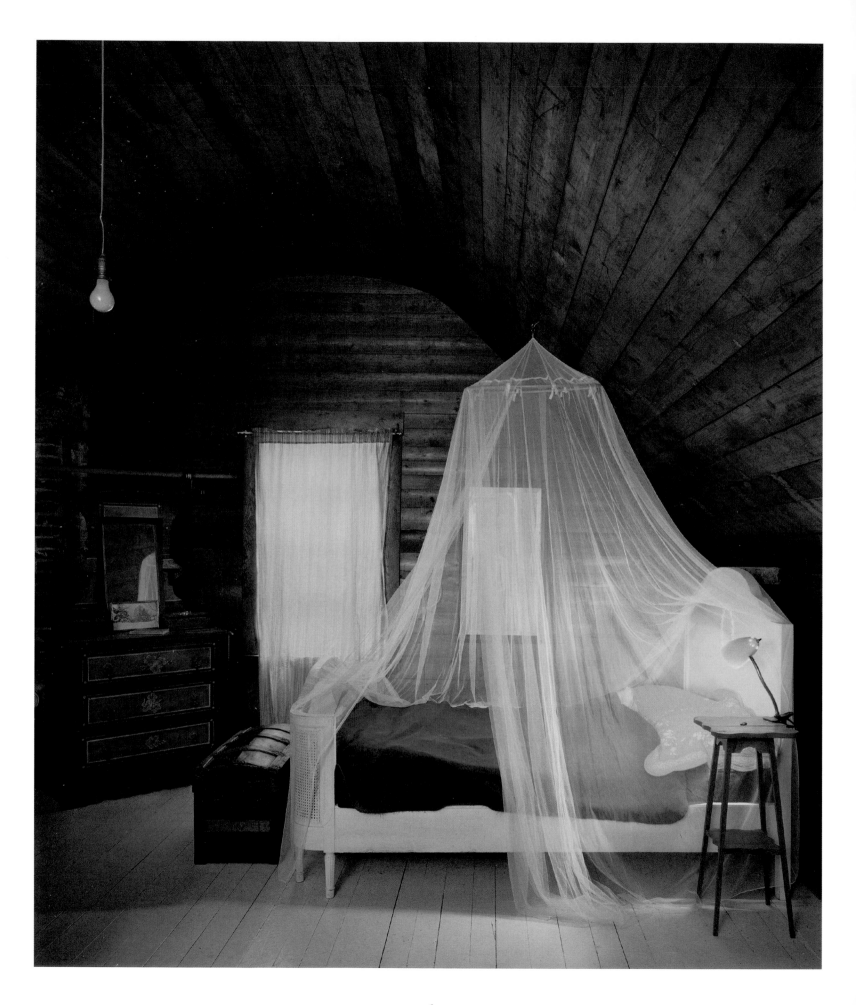

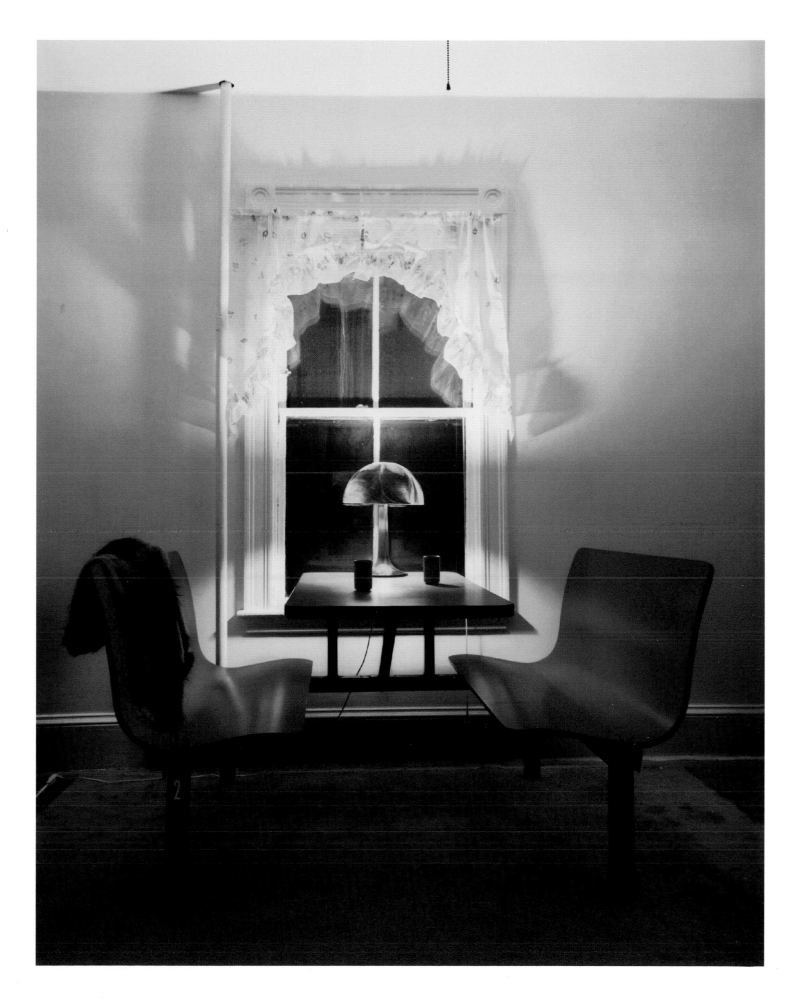

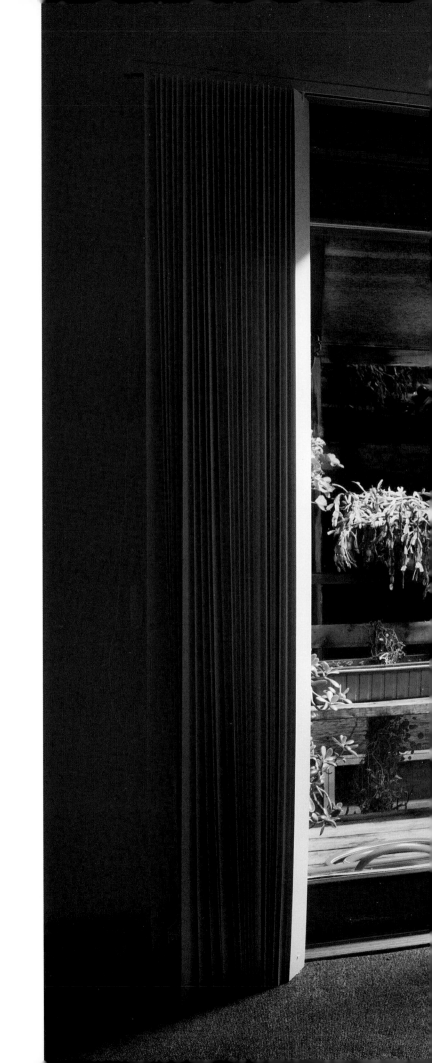

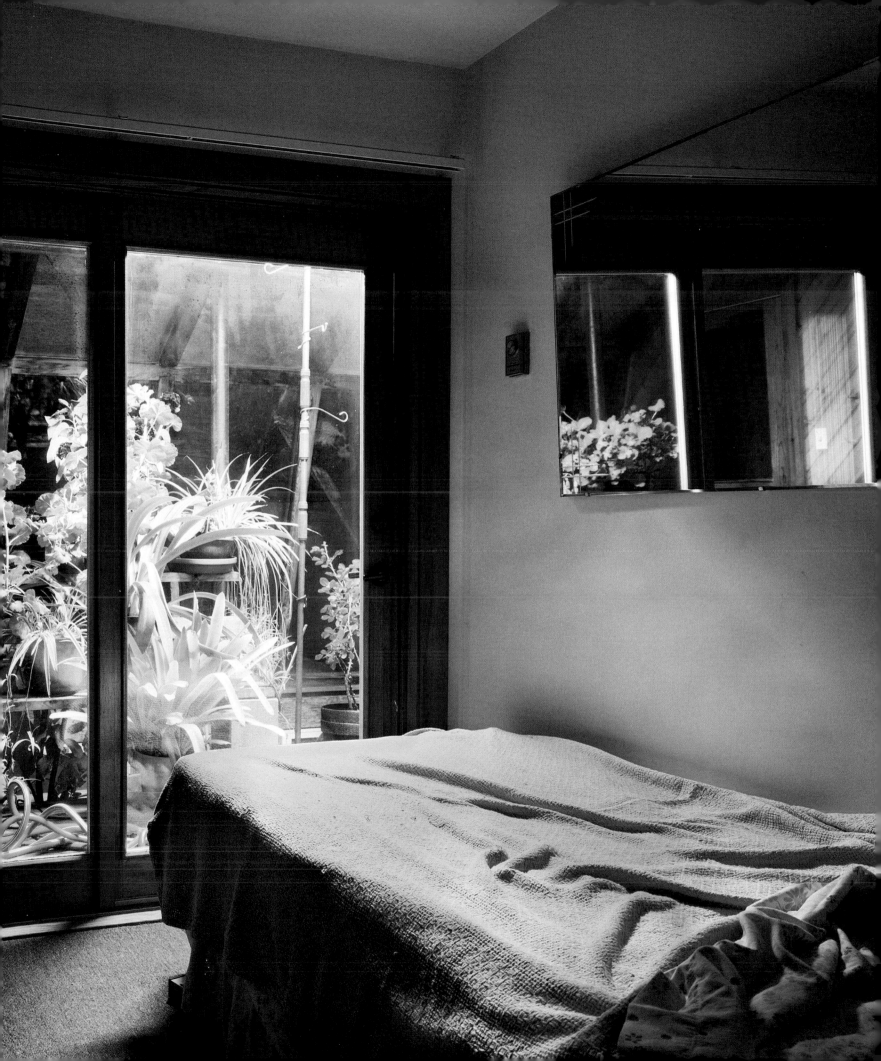

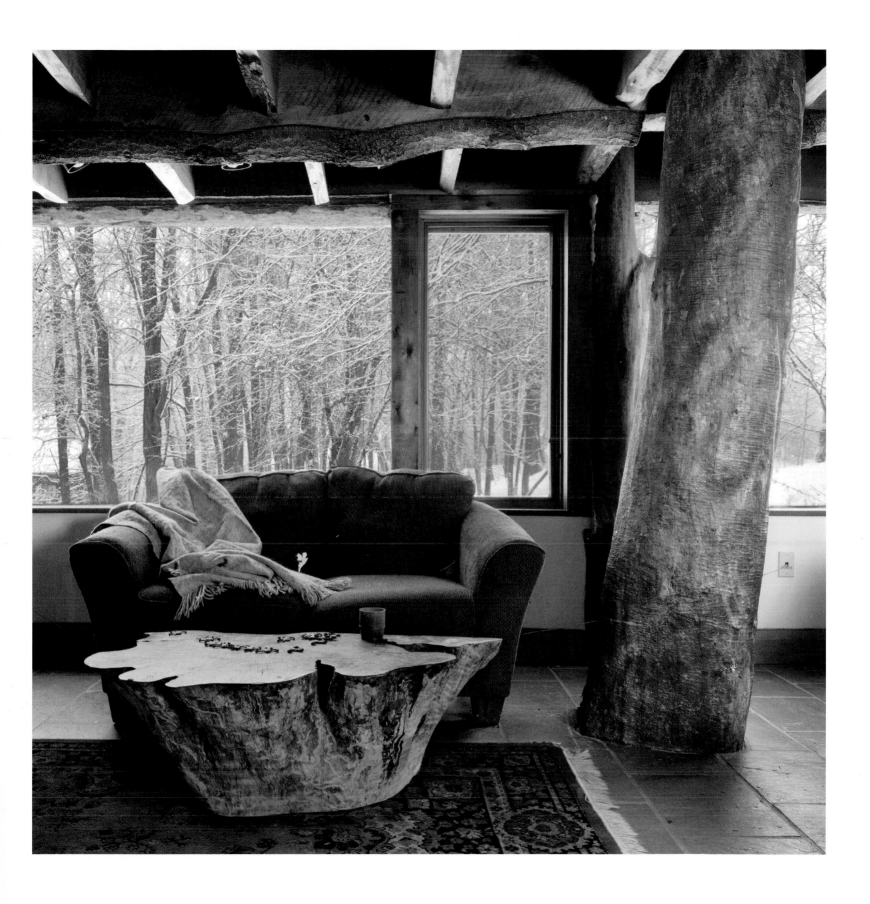

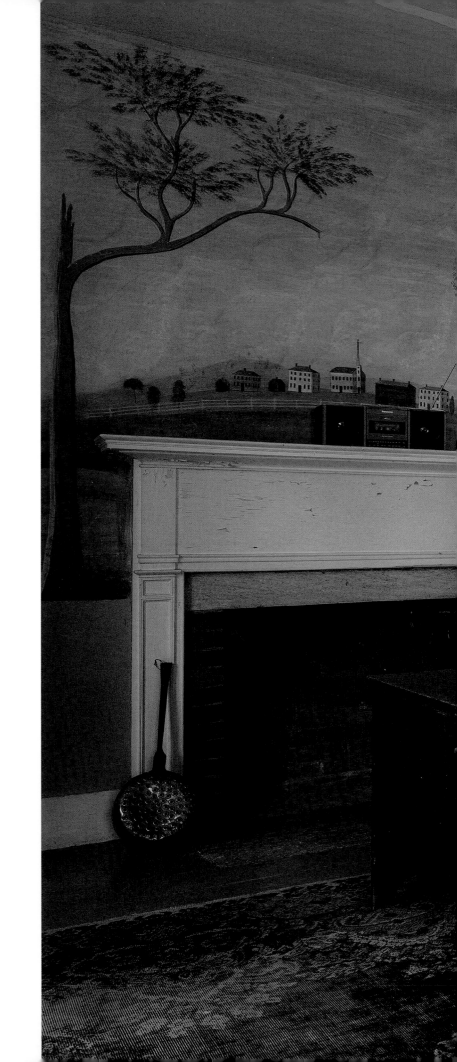

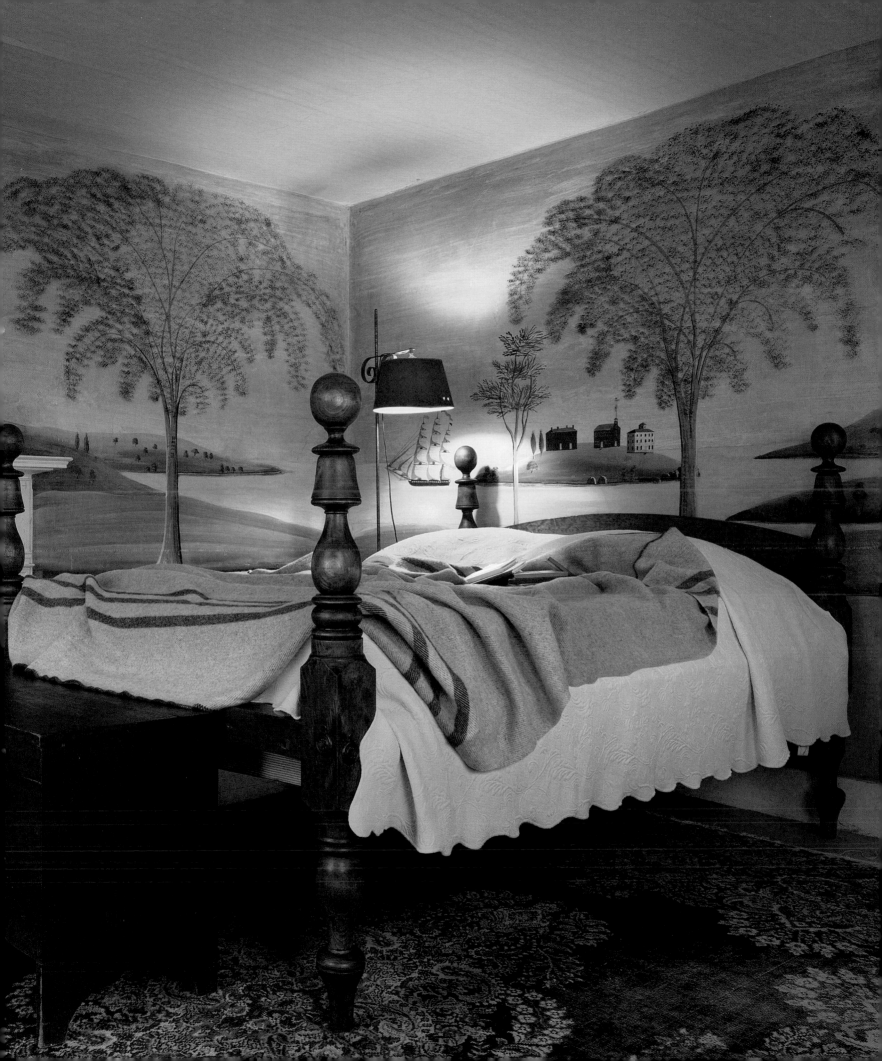

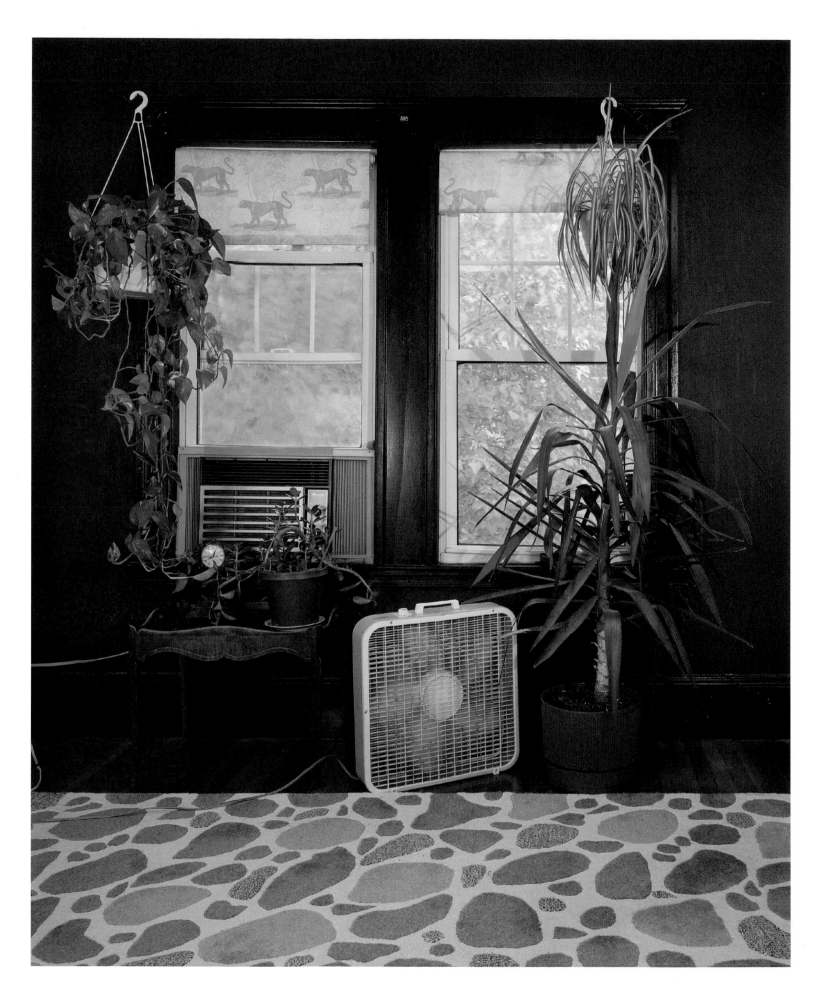

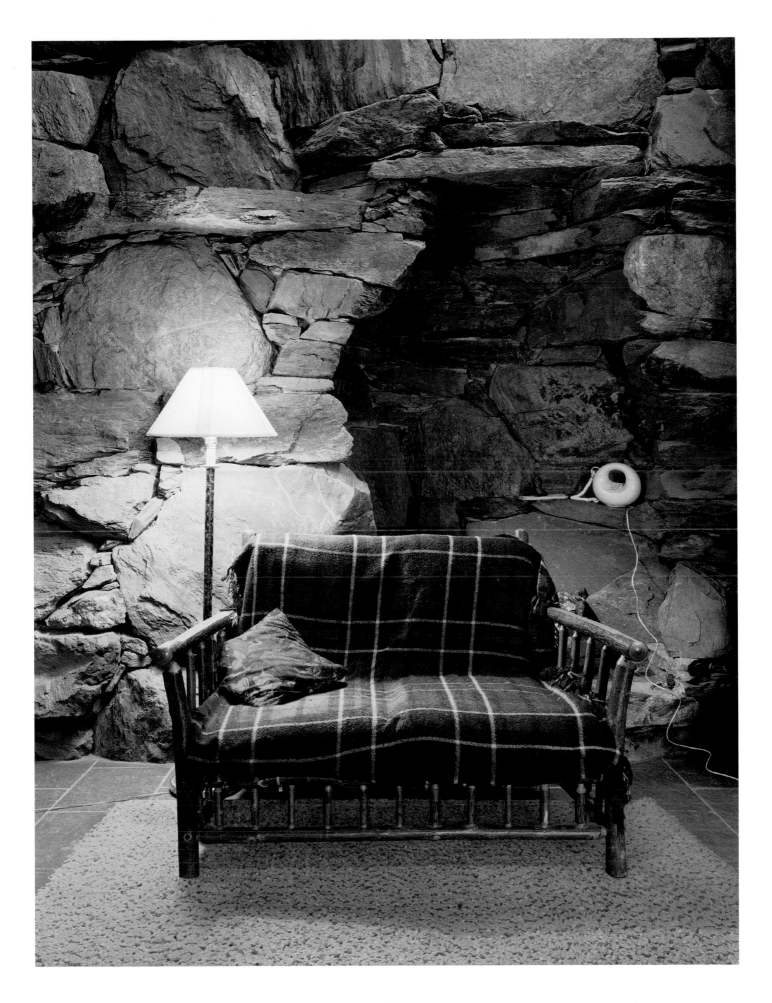

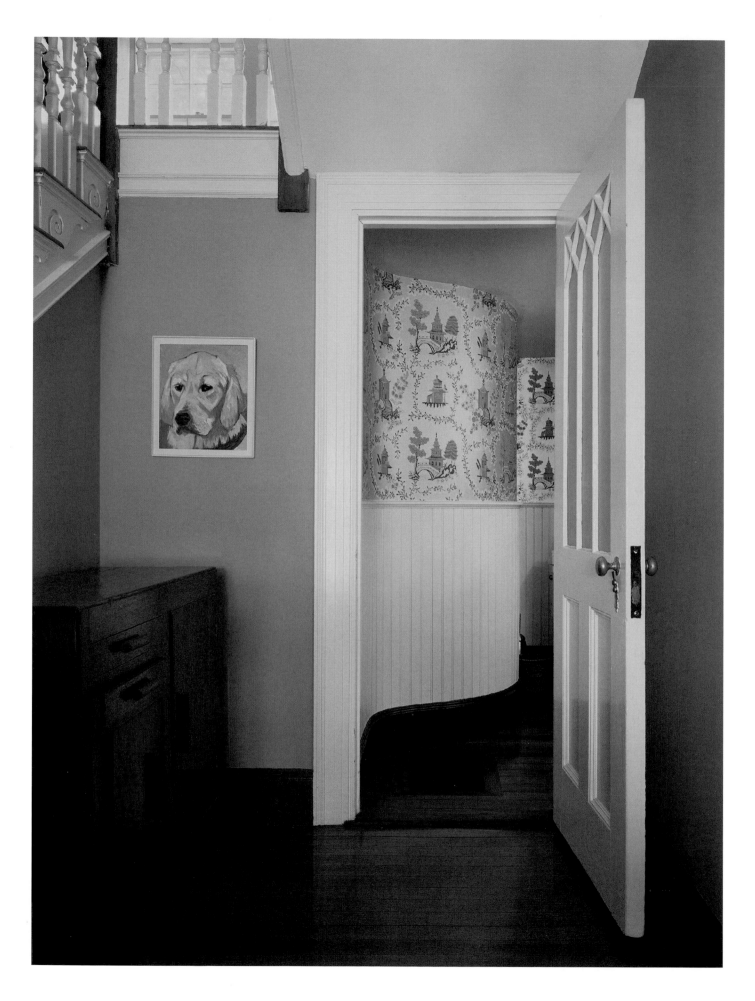

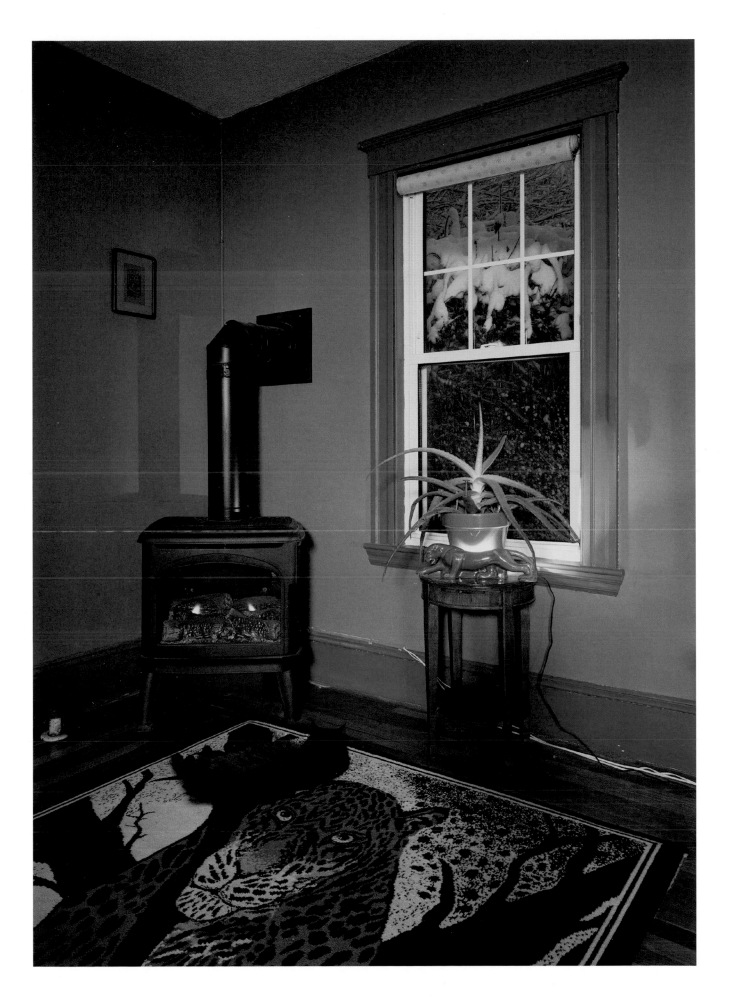

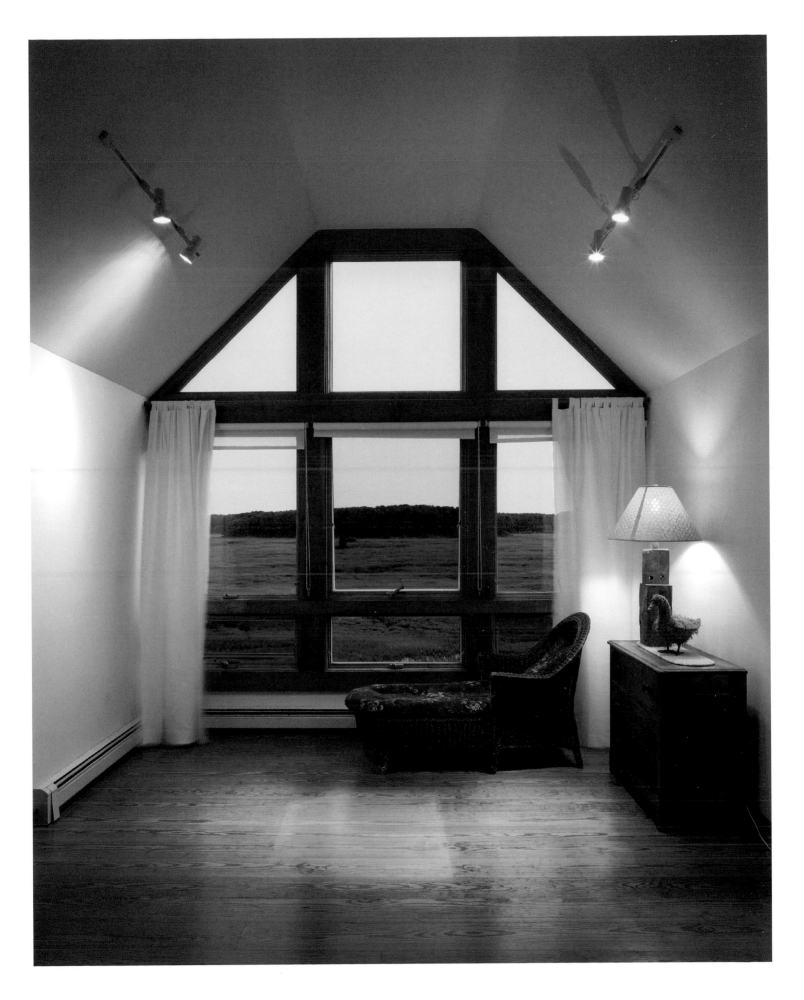

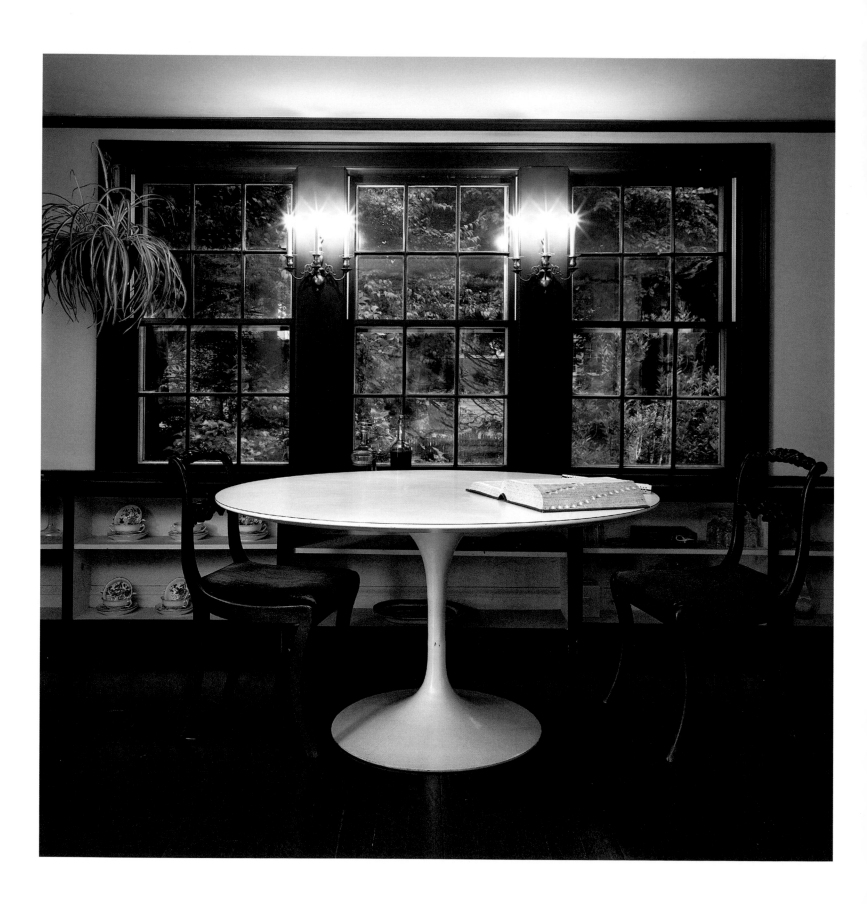

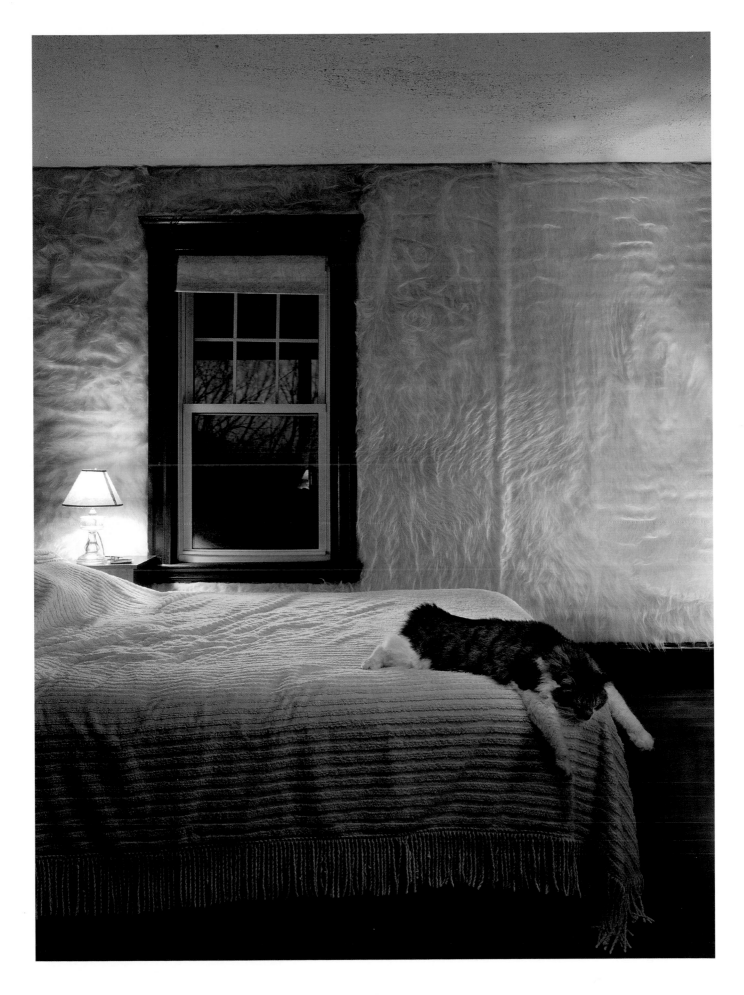

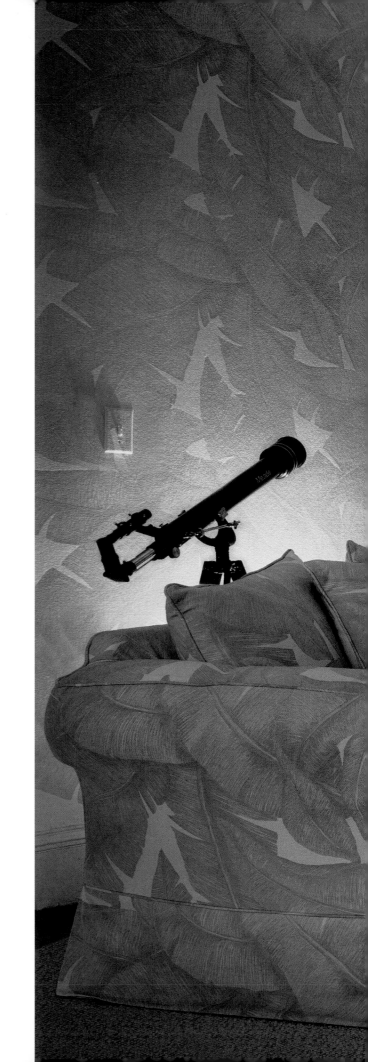

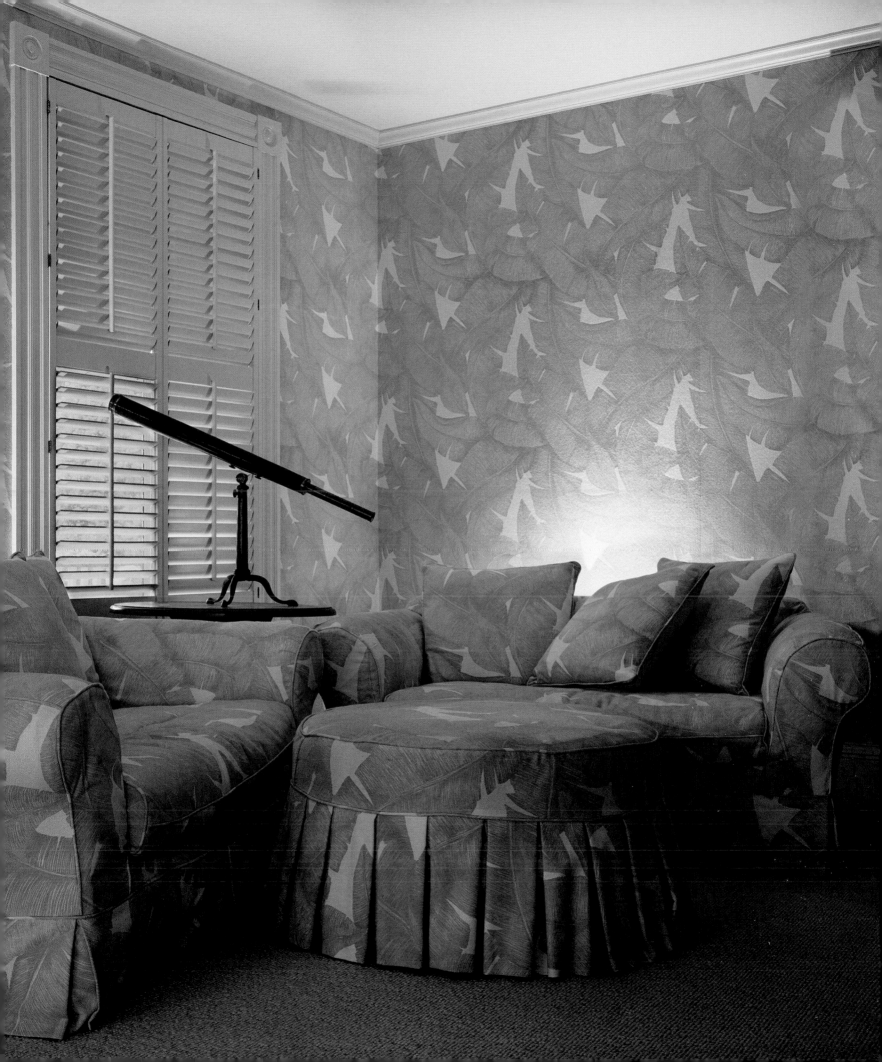

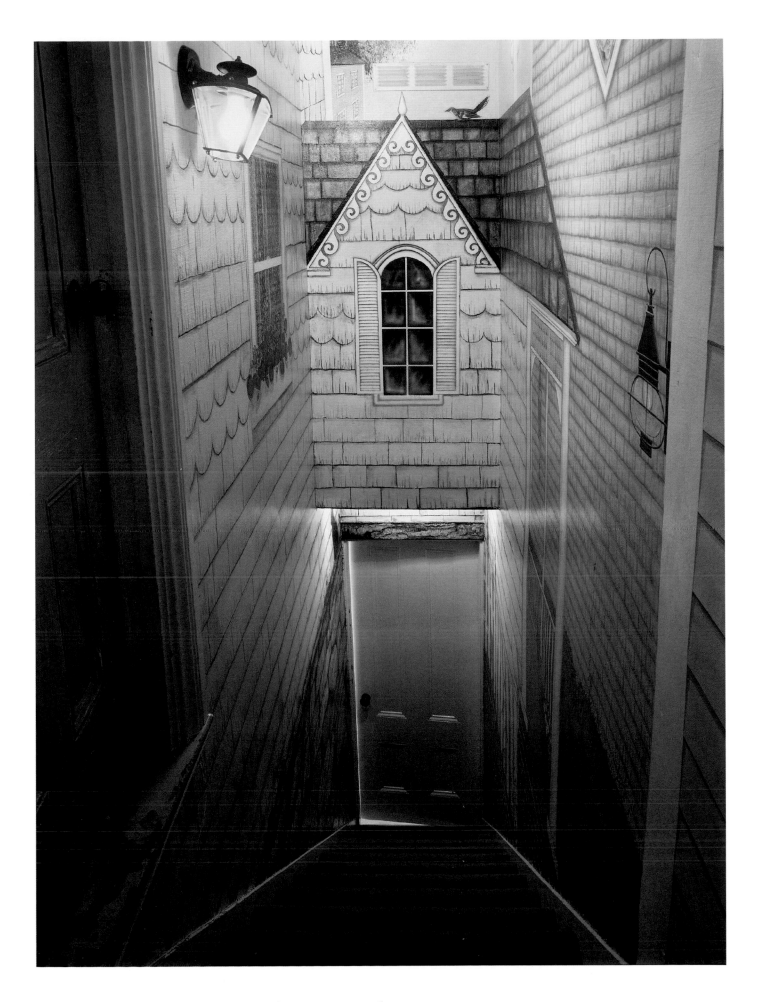

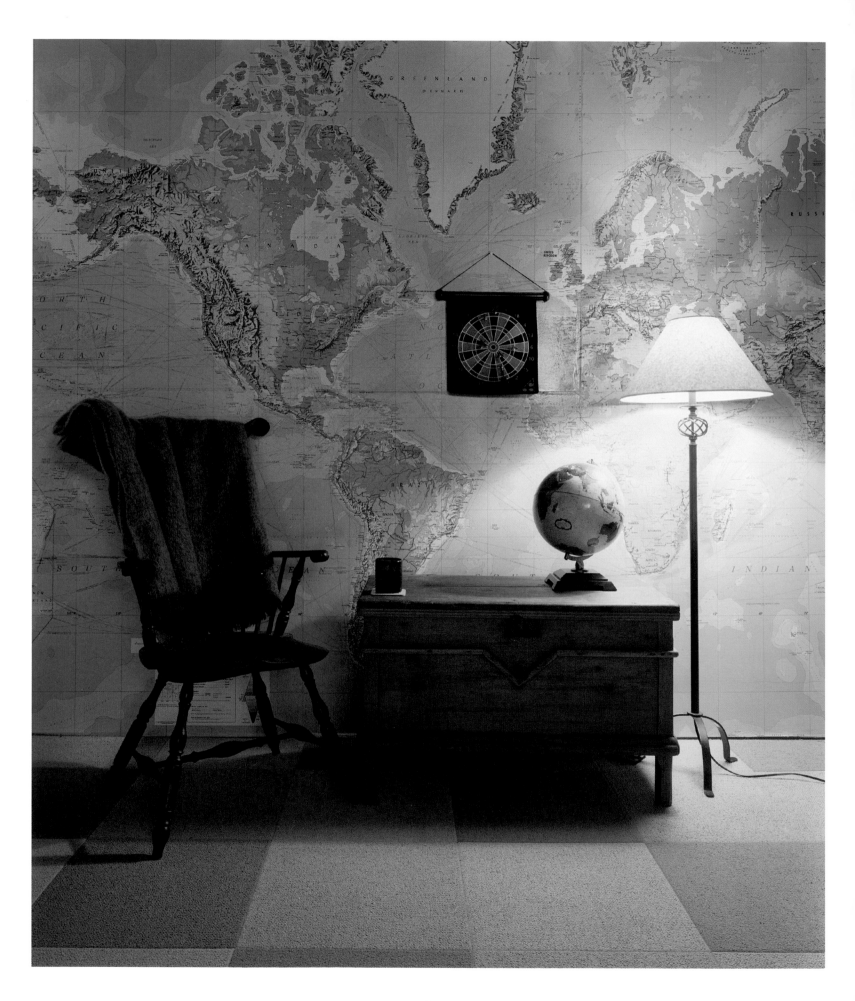

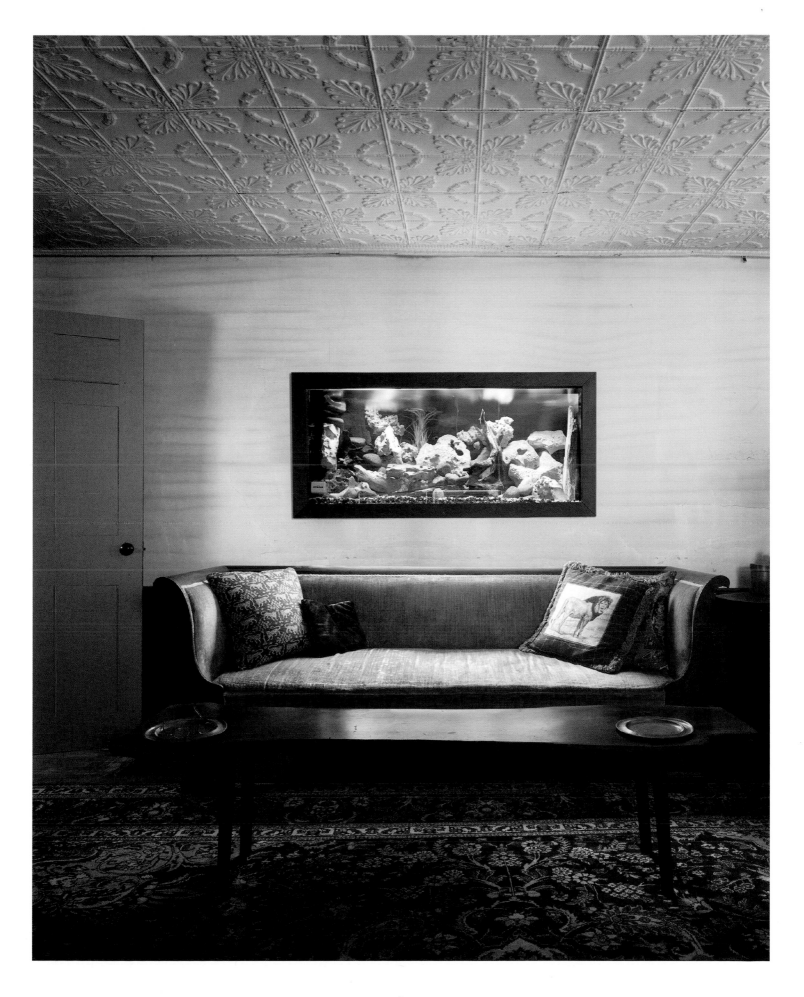

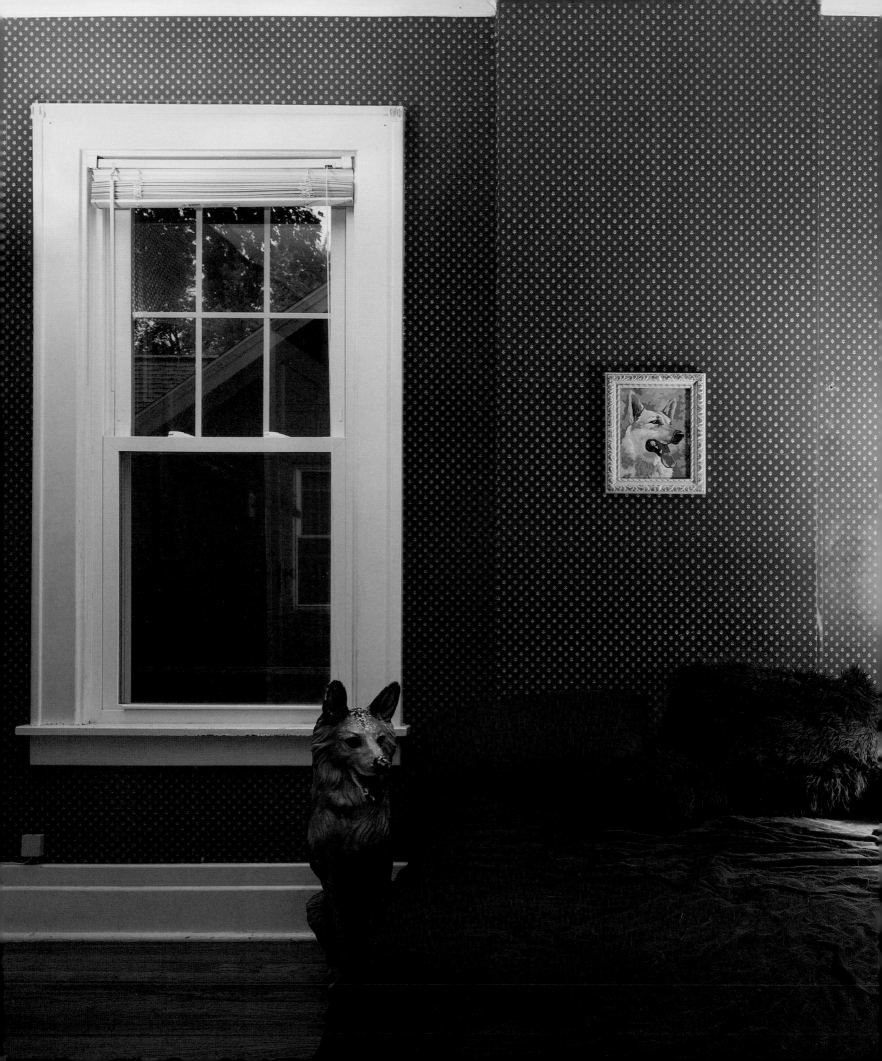

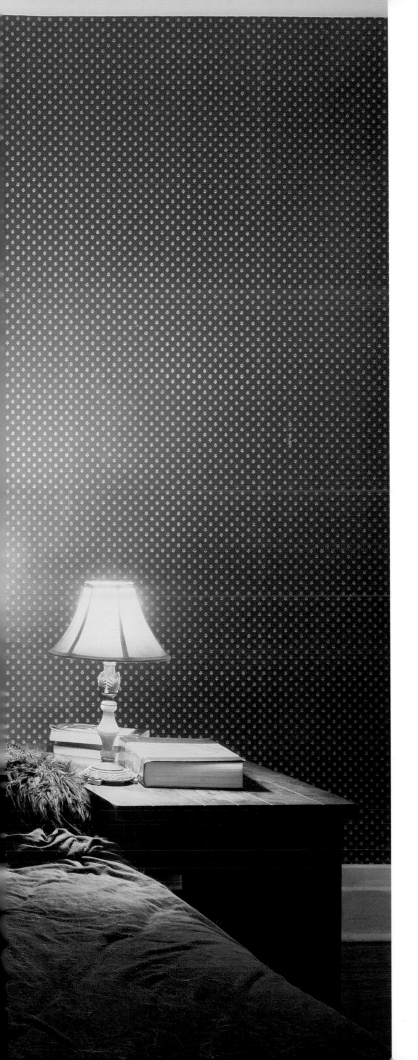

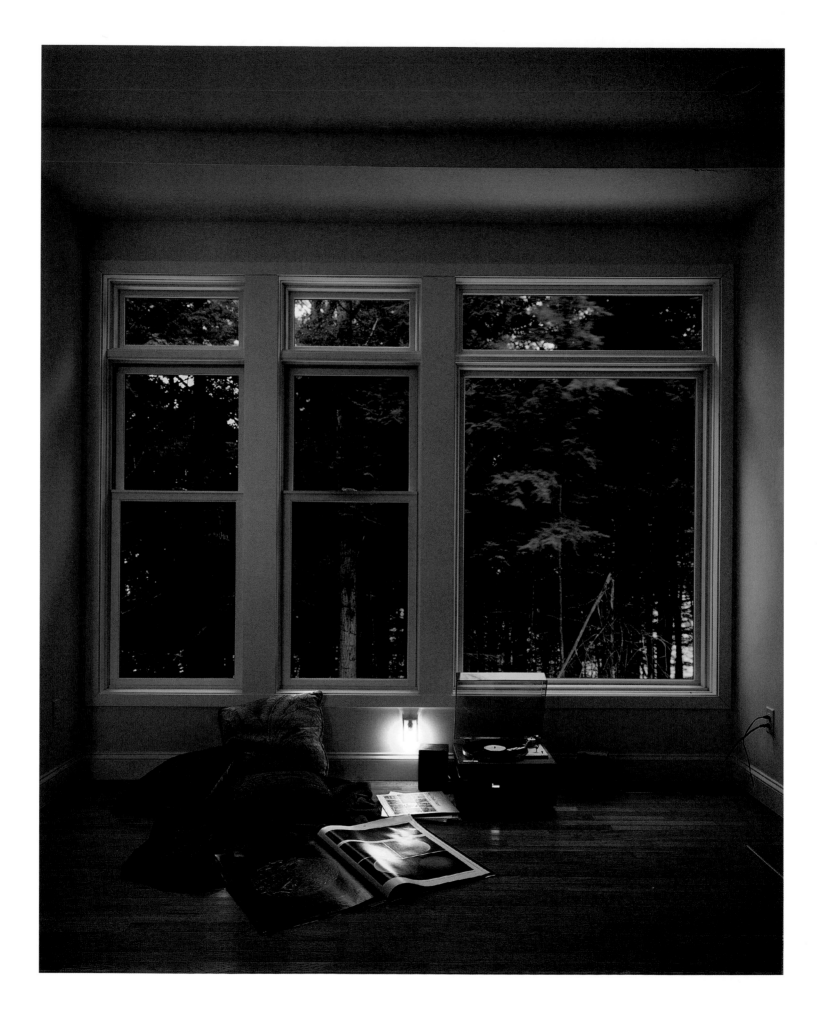

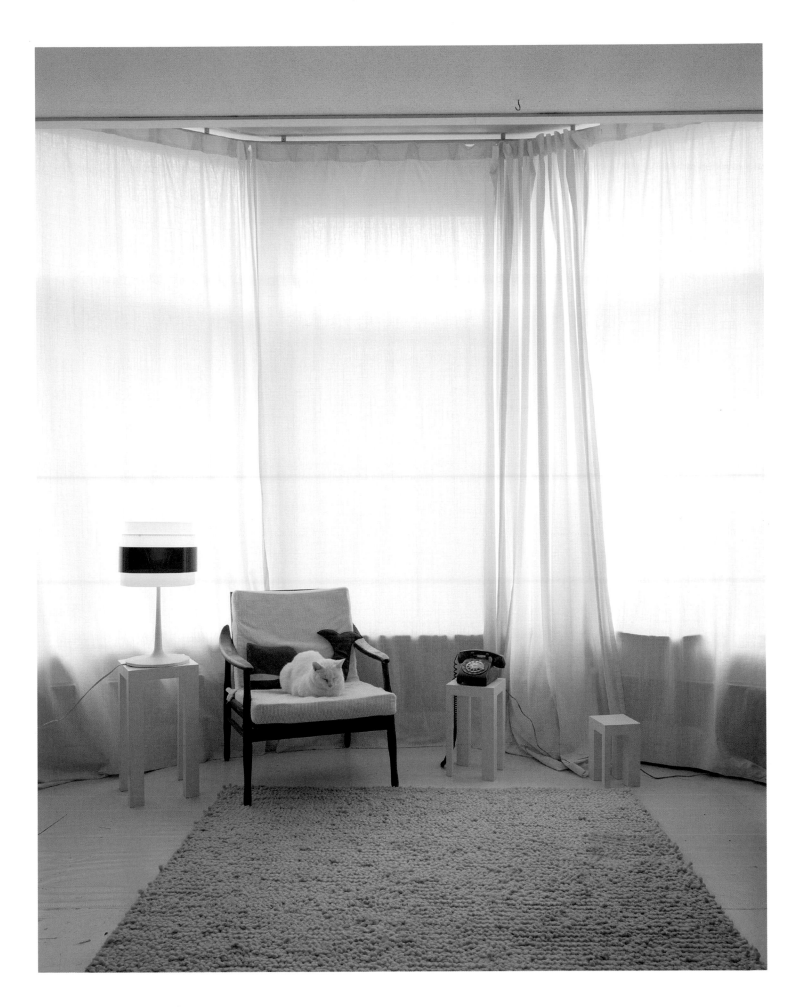

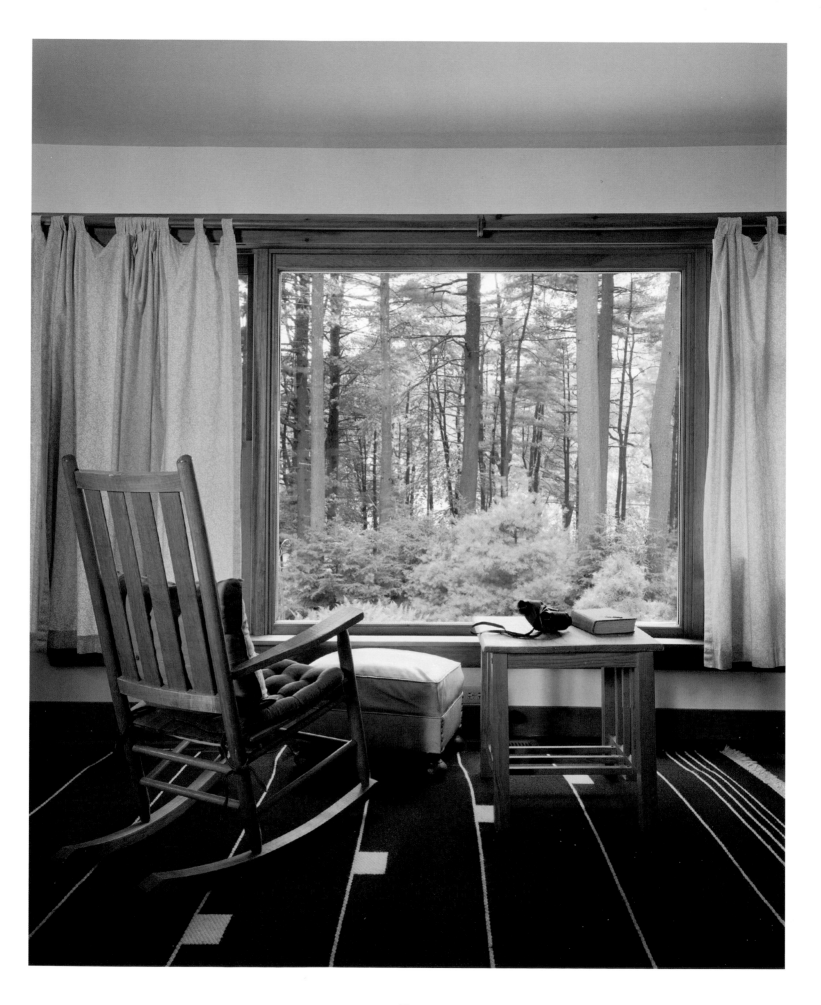

Appendix

LIST OF WORKS

Artist and Authors' Biographies

Sarah Malakoff was born in Wellesley, Massachusetts, in 1972. She lives in Boston and is Assistant Professor of Photography at the University of Massachusetts Dartmouth. Her work has been widely exhibited in both solo and group shows nationally and is included in several public and private collections. *Untitled Interiors*, a sixteen-page Artist's Project, was published in *Esopus Magazine* in 2007. She has been awarded fellowships from the Massachusetts Cultural Council in 2001 and 2011 and a traveling fellowship from the School of the Museum of Fine Arts, Boston, in 2011.

Linda Benedict-Jones is Curator of Photographs at Carnegie Museum of Art. Prior to this, she was Executive Director of Silver Eye Center for Photography. She has also served as Curator of Education at The Frick Art & Historical Center and she teaches courses in the History of Photography at Carnegie Mellon University which, along with the previously mentioned institutions, is in Pittsburgh, Pennsylvania. Before moving to Pittsburgh in 1993, Benedict-Jones was Curator of The Polaroid Collection and Director of Polaroid's Clarence Kennedy Gallery in Cambridge, Massachusetts.

Jen Mergel is the Beal Family Senior Curator of Contemporary Art at the Museum of Fine Arts, Boston. She opened the museum's first contemporary wing and collection galleries in 2011 and curated new series of exhibitions, including *Kristin Baker: New Paintings*, *Passages: Felix Gonzalez-Torres*, and *Sparking Dialogue*. Mergel was also curator for numerous exhibitions at Boston's Institute of Contemporary Art, including *Acting Out: Social Experiments in Video* and solo exhibitions by Eileen Quinlan and R.H. Quaytman. She has authored monographs for the touring survey shows *Tara Donovan* and *Charles LeDray: workworkworkworkwork*. She has taught at Harvard and Boston University and is a native of Boston.

ACKNOWLEDGMENTS

This book would not exist without the kindness, interest, and patience of all the people who so graciously let me into their homes and gave me assistance, freedom, and sometimes snacks.

Thanks to all those who have believed in the work along the way and have exhibited, published, funded, and otherwise promoted it, especially Bryson Brodie and Chad MacDermid of the gone-but-not-forgotten Plane Space, Aprile Gallant, Tod Lippy, George Slade, Paula Tognarelli, and the Massachusetts Cultural Council.

The love and support from my family, including Sarah and Zab Warren, Becky Duseau, and my mother, Judith Consentino, have been invaluable.

Jen Mergel and Linda Benedict-Jones have generously provided eloquent and insightful words to illuminate my work.
In addition, I am grateful to Charta, especially Giuseppe Liverani, Filomena Moscatelli, and Fayçal Zaouali, for believing in the project and for diligently and thoughtfully presenting it.

Thanks to these dear friends who are also my most trusted advisors: Karl Baden, Bill Burke, Thomas Canney, Victoria Crayhon, Jen Hale, Colleen Kiely, Tyler Linton, Anna Minkkinen, John Petrovato, Ken Richardson, Daniel Van Roekel, Jasen Strickler, and James Weinberg.

I am incredibly fortunate to have the life-long friendship of Gwen Allen, and my sister, Rebecca Malakoff. They have been instrumental in the progress of this book, as with all facets of my life.

Finally, this book is for my husband, best friend, and fellow photographer, Andrew M.K. Warren. His endless encouragement, counsel, and love have made all good things possible.

To find out more about Charta,
and to learn about our most recent
publications, visit

www.chartaartbooks.it

Printed in February 2013
by Bianca & Volta, Truccazzano (MI)
for Edizioni Charta